KILLING GROUND

In Memory

Of

Ann S. Porter

2003

CREATING THE NORTH AMERICAN LANDSCAPE

Gregory Conniff, Edward K. Muller, and David Schuyler,
Consulting Editors

George F. Thompson, *Series Founder and Director*

Published in cooperation with the Center for American Places,
Santa Fe, New Mexico, and Harrisonburg, Virginia

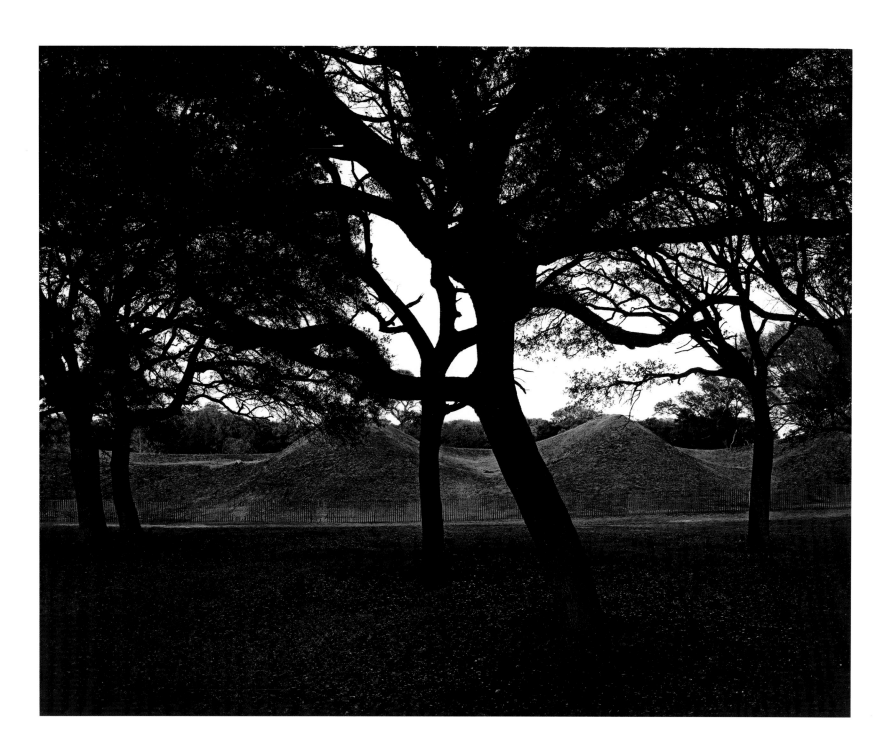

23 December 1864–15 January 1865 Interior of the North Face

3,800 American Casualties FORT FISHER, NORTH CAROLINA

KILLING GROUND

Photographs of the Civil War
and the Changing American Landscape

John Huddleston

The Johns Hopkins University Press, Baltimore and London

This book has been brought to publication with the generous assistance of the Andrea Frank Foundation and Middlebury College.

Printed in Italy on acid-free paper

9 8 7 6 5 4 3 2 1

The Johns Hopkins University Press
2715 North Charles Street
Baltimore, Maryland 21218-4363
www.press.jhu.edu

Library of Congress Cataloging-in-Publication Data will be found at the end of this book.

A catalog record for this book is available from the British Library.

ISBN 0-8018-6773-8

For those soldiers, living and dead, who have held visions of peace

CONTENTS

A NOTE TO THE READER

Black-and-white photographs were made during the Civil War unless noted otherwise. Dates indicate when the battles occurred.

The color photographs of the battlefields were made at the time of year when the Civil War fighting took place. When possible, the time of day of the combat was also duplicated. Most of the photographs were made in the areas where the heaviest killing in a battle happened. None of the photographs have been electronically altered in any way.

The figure given for the number of American casualties in each battle includes the number of Union and Confederate killed, wounded, and missing.

KILLING GROUND

ABOUT THE WAR

Six hundred twenty thousand soldiers died in the American Civil War. This figure surpasses the combined total of American dead from all other wars through Vietnam. The Union army lost 360,000 lives, including 37,421 black troops and 1,018 American Indians. Ten percent of all Northern males 20–45 years of age died, as did 30 percent of all Southern white males aged 18–40. Twice as many soldiers died of disease —mainly dysentery, typhoid, and pneumonia— as died in battle. Other figures for the Union army include 4,494 drowned; 520 murdered; 391 suicides; 104 killed after capture; 64 executed by the enemy; 267 executed by U.S. military authorities; 313 deaths from sunstroke. In all, 500,000 soldiers were wounded. Two out of five soldiers were killed or wounded. In the South, 50,000 civilians, black and white, died of war-related causes, primarily malnutrition and disease. The principal prewar occupation of the soldiers in the Civil War was farming.

The sites of the massive, suicidal charges— Shiloh, Malvern Hill, Antietam, Fredericksburg, Gettysburg, Spotsylvania Court House, Cold Harbor, Kennesaw Mountain, Franklin —remain powerful testaments to desperation, hopelessness, and resignation. The rifle's greater effective killing range, 400 yards compared with the smoothbore's 100 yards, made the frontal charge outdated. The Union veterans at Cold Harbor in 1864 knew that an all-out charge across mostly open ground against a well-prepared Confederate position would be disastrous. They wrote their names on pieces of paper and pinned them to their uniforms so they could be identified later. Seven thousand Federal soldiers were killed or wounded in twenty minutes.

Conscription was first instituted in the United States during the Civil War, by both sides. The worst civilian riot in American history occurred in New York City in 1863 because of the institution of the draft. At first directed against conscription officers and property, the protest soon turned racist, and blacks were beaten and lynched on the streets. Union troops, many having just fought at Gettysburg, finally took control of the city's streets by firing grapeshot from cannon into the mob.

Was the war about slavery? Certainly not at the beginning. Although the issue was deeply implicated in Southern society and in the political status of westward expansion, most soldiers would not have included slavery among their reasons for going to war. Union white men's contempt for colored peoples was very similar to that of their Confederate counterparts, the majority of whom did not own slaves. Abolitionists were a definite minority. The voices of free blacks, even those who later wore the Union uniform, were generally ignored. After the Emancipation Proclamation was introduced in the second year of the war, slavery did become more of a focal point. By the end of the war a majority of Union soldiers supported ending slavery. But the continuing legacy of blacks' struggles for civil rights in the North and the South suggests that for most Americans the question was not paramount. Instead, slavery was recognized as being inextricably linked to the primary issue of union or division of the country.

Personal economic need, community pressure, idealistic convictions about political free-

3

dom, duty to one's country, honor among one's peers, and religious belief were among the various reasons for enlisting. Many joined for the adventure; naiveté about the grisly realities of war contributed to the willingness to fight. Specific regional motives also existed for sectors of the population. Americans of the northern Mississippi basin could not tolerate the possibility that navigation of the Mississippi River, the lifeblood of their commerce and their culture, might be obstructed. The invasion of their state by outside forces was reason enough for many Southerners to enlist. But these issues only became concrete after the war began. A general enmity and suspicion festered for many years before the actual shooting.

Each side had come to view the other as a threat to its way of life. Each side's simplistic assessment of its own society and that of the other paradoxically produced a false security and an exaggerated fear. Resistance to change led to the extreme change brought about by wartime conditions. Anxiety about modification of the social order was replaced by the extreme fears of actual war and drastic changes in American society as a whole. From another perspective, the Civil War resulted from a failure to compromise, from a failure to use the methods in place to work out the differences peacefully. Americans also supplanted political questions and personal problems with the ancient myths of patriotism, heroism, manliness, the evil enemy, and eternal reward for martyrdom. Under stressful conditions these unconscious forces became more vigorous. Such romance continues to color much of the thinking about the Civil War.

Once the war began, on both sides a divided citizenry united behind the propagation of the war. As the struggle intensified, and it became apparent that the future structure of the country was being shaped, political ideals, such as the abolition of slavery, became more pronounced.

For blacks, the war was decidedly about slavery from the beginning. The anonymous black Union soldiers were true American heroes. Their humble past, their unambiguous and noble motive (to vanquish slavery), the abuse they endured at the hands of people in the North and the Union army, the prospect of being murdered or enslaved should they be captured by the enemy, and the consistent bravery with which they fought all make them worthy of that title. The black soldiers did not achieve social equality, but they did help the nation to take the first step, that is, to put an end to slavery.

Some historians have assessed the Southern chances for victory in the Civil War as unlikely but still much better than the odds of the colonists during the American War of Independence. The internal disunity that plagued the South was not as pronounced as that of the thirteen colonies. The Northern enemy was more populous, better equipped, and more industrialized, but again, these inequities were less severe than those faced by the early American revolutionaries against the world's leading power. Both the South and the colonists had the advantages and the disadvantages of fighting on their home turf. The North, however, was physically closer and more vitally interested in the war than was Great Britain. The South did not have the same dearth of experienced military leaders that the colonists had. If the

South had adopted a more patient, more defensive posture, similar to the one demanded of eighteenth-century Americans, the results might have been different. But in such thinking we neglect the importance of the political bases: the American colonists were creating a new, fundamentally different form of government, one based on individual freedoms and the pursuit of liberty through democracy. The Southern platform of secession could not approach such ideals.

The experience of the Civil War shaped the self-reliant nature of the American into a character more amenable to serving in large, hierarchic institutions. Total war spawned powerful, national systems of government, transportation, and industry that operated under centralized control, replacing former localized and individual power bases. When the war began, states issued their own paper currency; citizens and militias owed their allegiance to states. By war's end both North and South had a national paper currency, a national definition of citizenship, and national conscription. The national military organizations served as models for large

corporate structures of the future. Primary resistance to this capitalist growth had come from Southern agrarianism. The South was destroyed, and the Northern ideal of the independent craftsman, businessman, or farmer was eroded in the process of trying to assert it. Hierarchy, subordination, and obedience to political and economic institutions became the new American way.

The steamboat, the railway, newspapers, and the telegraph enabled the United States to maintain an evolving unity. These new mechanisms of travel and communication kept the various areas of the United States from diverging so much that permanent splits would occur, with North America becoming like Europe. But these inventions came too late to reconcile the previous differences between North and South; in fact, they aggravated the problem, for the expansion westward that new technologies encouraged had to be tied to one side or the other. The resolution of the Civil War permitted the United States to resume its unique formation, more conscious than ever of its unity. The forces of assimilation have made the diverse peoples and geographies of

the United States into a country of marked similarity.

"All history is the interpretation of the present," wrote George Herbert Mead (*Selected Writings,* 298). Questions raised during the Civil War about centralized government, race, economic development, expansion of the American system, types of military violence, and the reportage of that violence are still current. The Civil War is often called the first modern war because of the large number of casualties, compulsory military service, the use of longer-range weaponry, ironclad warships, trenches, and scorched-earth policies against the civilian population. Extensive photographic coverage was also new, breaking painting's long and popular tradition of the glorious depiction of warfare.

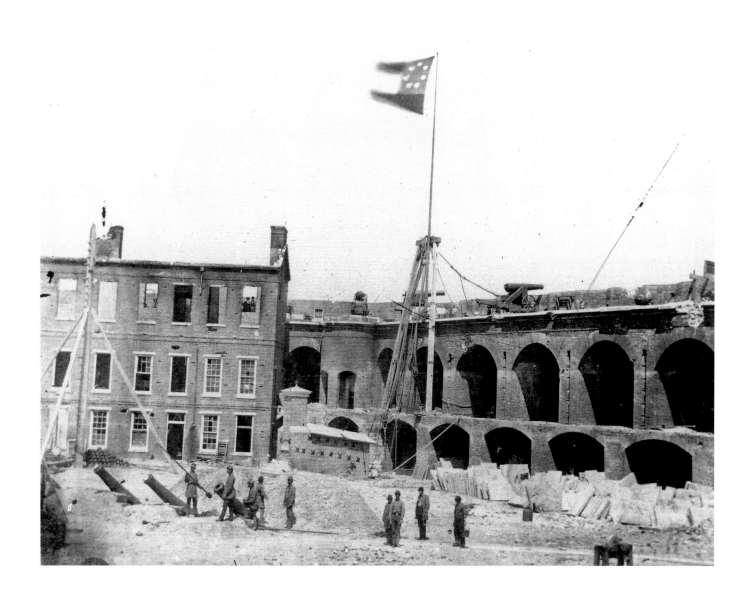

ABOUT THE WORK

Personal background expands and limits ideas about the divisive Civil War. In our *united* states, which grow more and more homogenous, people nevertheless maintain a fundamental sense of regional attachment. We can relocate with relative ease, and this travel tempers local arrogance, but the increased options for residence make the choice of a particular area significant. Family, business, climate, and physical surroundings all inform this loyalty, as do memories, especially of one's childhood connections to the land.

I was raised with the common but peculiar blend of pride in the United States of America and pride in the South. I was adopted into a military family (for several generations back) with ancestors who had fought for both the United and the Confederate States of America. In the twentieth century my relatives fought and were killed and wounded in the two world wars, Korea, and Vietnam. I was born on the massive U.S. Army base at Fort Bragg in North Carolina. Next to the base is Fayetteville, half of which is a typical, conservative, small Southern town, the other half a sleazy section of 1969 Saigon. My biological father is from Iowa. Old blood relations may have served in Sherman's army, which fought at Monroe's Crossroads, now within Fort Bragg, and burned much of Fayetteville during the war.

The impetus for this project came from living near Civil War battlefields and experiencing their beauty and power from an early age. My father's military knowledge and presence brought substance to the events that took place on those fields. I felt excitement, chaos, pain. I felt respect for the sacrifice and heroism of the soldiers, and I felt the fear of having life itself so removed from one's control. These emotions coexisted with the serenity and physical beauty of the land.

A major emphasis of this project is the resonance of history in the landscape. Are physical and spiritual traces of the great slaughter still present in these places? Remains of blood and bodies, as well as the instruments of their destruction—the lead of the Minié balls and the iron of the artillery rounds—still exist in the earth. Much of the land was physically altered with the construction and destruction of defensive earthworks, whose weathered remains are clearly visible.

Less direct physical effects also exist. The Civil War heavily influenced the economic structure of the United States, which clearly affects the land. The establishment of national cooperative networks of currency, transportation, and deregulation across state lines paved the way for rapid industrial development in the future. The unification of government and the centralization of power encouraged uniformity in ecological politics and practice, destructive or protective.

Spiritual traces are more elusive. The search for the latent energies of these battlefields inevitably leads back to histories, metaphors, and myths. The tensions and sufferings of the soldiers involved in the riotous circumstance of these locations 140 years ago may come to us through written descriptions, the color of the soil, or collective memory. The histories and diaries we read are mental abstractions of the historical events of the place. Thoughts of the living and dead become enmeshed, and

these particular ideas are inextricably linked to the land.

The battlefield is a talisman, a physical focus of violent acts. The land sparks personal memory of wartime accounts. It triggers a shared, deeper memory of human conflict and suffering, and it evokes a way of perceiving that sees in a leaf falling a man falling, a fallen man seeing a leaf falling. In the amphitheater of death many visions may have been the final sight of closing eyes.

Violence engenders emotional extremes that may affect the participants for an extended period. When I was at the Armed Forces Institute of Pathology, making copies of its photographs of Civil War wounded, a box was received from a World War II veteran. Inside the box were the remains of a Japanese soldier killed in the Pacific that the American soldier had managed to bring home and keep in his basement for forty-five years.

Those removed from the killing can also become disturbed. When I was photographing the site of the murder of surrendering Union soldiers by William Quantrill's guerrillas in 1863, now a neighborhood of Baxter Springs, Kansas, I asked a woman if I could photograph her house and explained my interest to her. She did not care much about the Civil War massacre, but she literally pleaded with me for information about a tree on her property that she had been told served as a gallows long ago. I had nothing to offer her, but the possibility that the hanging tree was in her backyard had such a grip on her mind that she would barely let me go.

At one time I had thought of following my father's path to West Point, but the winds of 1970 blew me in a different direction. This work is a salute to the longstanding military tradition of my family that I chose to break.

THE CONTEMPORARY PHOTOGRAPHS

To make my photographs I used a large wooden camera (8" x 10" film size) similar to those used by the photographers of the Civil War. The resultant method of working was slow and deliberate, with time for the photograph to be shaped by thought.

Exact physical location of the battlefields was crucial for my work. Knowing precisely what happened on the specific site I was photographing gave me an important context and demanded a certain rigor in seeing and interpreting. For the well-known battlefields this information is readily available. For the lesser-known battlefields the research necessary was sometimes extensive. My basic method was to compare maps made during or immediately after the war that detail the troop movements with current U.S. Geological Survey maps. For written accounts of the battles I turned to the considerable literature on the Civil War, and when that failed, I went to the official records (United States War Department, *War of the Rebellion*). For some of the battlefields there are no maps or local markers. In such cases local libraries, state historical societies, local historians, historians attached to the nearest national battlefield park, reenactors, municipal governments, local landowners, or families who had lived in the area since the Civil War were of considerable assistance. Photographing the

battlefields within days or weeks of the date of the battle greatly complicated my travels, but it was necessary to provide whatever visual correlates remained in the light and foliage. Many of the less developed battlefields are naturally transformed from season to season.

I was open to the complexities of the Civil War, to its implications for our present culture and landscape, and to the ways of understanding these issues. These concerns are worked into the images through specific content, metaphorical reference, and formal structure. By *content* I mean "DIE NIGER" scrawled on the road on the Jonesboro battlefield (see p. 131), or the World War II military hardware on the Fisher's Hill battlefield (p. 137). By *metaphor* I mean the central gash in the earth on the La Glorieta Pass battlefield (p. 117) or the implications of Jim Crow segregation in the water fountain with the handmade signs reading "MEN" and "WOMEN" at the New Bern battlefield (p. 129). *Formal structure* encompasses color, notably red in many of these photographs, and the out-of-focus close foreground, suggesting a soldier under fire hugging

the earth, trying to locate his enemy in the distant tree line, as at the Wilderness battlefield (p. 149).

Environmental changes to the battlefields create a different sense of time for measuring human chronologies. A geologic scale of thinking arises from a battlefield like Blair's Landing, Louisiana (not included in this book), where the site of the Civil War dock on the Red River is now dry, the river having moved a half-mile to the east. Several of the forts along the Mississippi have also lost their strategic positions because of river movement. When I photographed the Peachtree Creek battlefield, near Atlanta, a sign warned of a health risk from pollution, a new type of danger upon the land. While the greater timelines of natural history do not excuse human transgressions, they do suggest that change is the nature of existence.

When I was in my early twenties I revisited Asheville, North Carolina, where I had lived in my early teens. As I walked over ground I had once played on, memories I had thought were long gone flooded back. Are there not also cultural, shared memories that can be evoked

by touching the same land where our ancestors had significant experiences? If that land is fundamentally altered, is the memory dimmed? Civil War battlefields are touchstones for memory. They contain traces of great struggle, commitment, and suffering. They are killing grounds, sites of the end of the body. Compelling, visceral qualities are demanded in their depiction. Photographs of such places are gravestones. Their visual beauty opens centers of emotion and intuition. I do not intend for my photographs to encourage the dramatic—quite the opposite. A photograph that appears almost ordinary and yet evokes a sense of truth and beauty is all the more meaningful. The mundane makes up most of one's life, and it is to everyday life that we need to feel connected.

THE HISTORICAL PHOTOGRAPHS

The historical photographs included in this book are extraordinary documents of the events, societies, and mythologies of the war. Their diverse contents are supported by a variety of visual and conceptual approaches

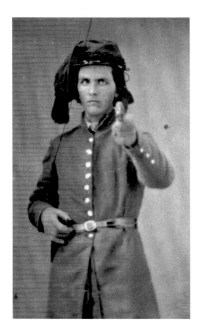

Fig. 1. William Cavender, of Georgia, a Veteran of the Carolinas Campaign, with Pistol

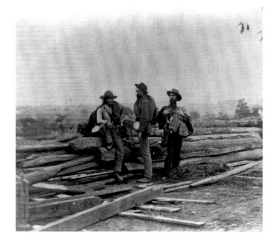

Fig. 2. Captured Confederate Soldiers at Gettysburg

that is especially remarkable given that the medium was only twenty-five years old at the time. The photographic process was cumbersome, but Civil War photographers mastered the techniques and infused their work with heartfelt emotion. Their acute, distilled observations maintain a sense of urgency even today.

Portraiture was well established by 1861 and was the primary business of working photographers. The soldiers, in anticipation of their absence from home, perhaps forever, and to record their participation in the important events, flocked to photographic studios to secure images of themselves to give to loved ones. The simple, straightforward portraits, such as that of Thomas Sheppard (p. 80), strike me as the most powerful, but some of the pictures employing backdrops, symbolic but sometimes strange and silly, such as that of an unidentified black soldier (p. 156), are also moving. These men appear composed, despite the pressures upon them, as they look into the eye of time. The more contrived portraits, showing heavily armed young men in staged postures of killing, are double edged (see Fig. 1).

I found no portraits that pretended their subjects were being killed.

Group portraiture was equally diverse and successful. Look at the compositional beauty of the figure placement and the unbowed postures of captured Confederate soldiers at Gettysburg (Fig. 2). Wounded Union soldiers from the Wilderness and Spotsylvania confront the camera with dignified sorrow as still more wounded arrive from the right (Fig. 3). The fallen tree in the foreground of the plate showing the men of the 13th Connecticut sounds an ominous note (p. 136). Timothy O'Sullivan photographed Grant and his staff in a more candid manner. His photograph taken on 21 May 1864 is archetypal in its portrayal of a group of powerful men huddled together plotting, seen from outside the circle (Fig. 4). George Barnard's 20 July 1864 portrait of Sherman and his generals (p. 134) is a predecessor in content and form of today's photographs of corporate boards in their meeting rooms, serious, in business uniform, with often a nod to their ancestors in power. (In Barnard's photograph two of Sherman's staff place their right hands partially inside their

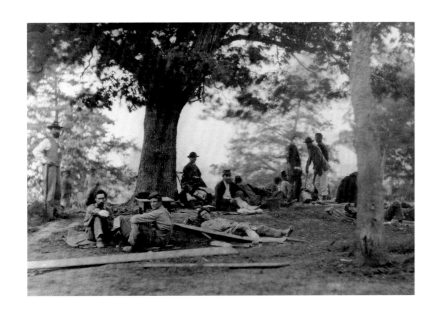

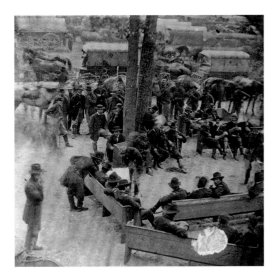

Fig. 3. Wounded Union Soldiers from the Wilderness and Spotsylvania in Fredericksburg

Fig. 4. On 21 May 1864 Grant, leaning over the bench, and his generals plan the next move in the Union's final campaign against Richmond.

coats, like Napoleon.) A model of hierarchy for future America was being set. But the system was in transition in 1864; these leaders were still expected to face the dangers of combat along with their men: note the empty sleeve.

The notion that photography can preserve extended to the deceased. Photographs of famous or infamous dead individuals, such as that of Turner Ashby (p. 44), followed the tradition, started with earlier daguerreotypes, of memorializing the dead or began the tradition, still extant today, of the state's assuring the citizenry that justice has been done (see the photograph of William Anderson, p. 92). The photography of groups of dead soldiers on the battlefield varies from the brutal directness of bodies dumped into mass graves (Fig. 5) or

decayed corpses (see the photograph of Federal dead, p. 32) to poetic treatments in which Death hovers over its victims, personified in blurred background figures (*Union Dead,* p. 108) or the wind in the trees (*Soldiers' Burial,* p. 56). *Antietam Battlefield Grave of John Marshall* (Fig. 6) shows soldiers posted near Marshall's grave as if attempting to protect him from his fate. Barnard's *Scene of General McPherson's Death* (Fig. 7) conveys the absolute absence that death brings. All of these photographs were made to be remembered. They mark us, as death marked Civil War America.

The practice of medical photography expanded greatly during the war, documenting new techniques and treatments. Grimly holding signs bearing their names and army units, their damaged anatomy prominently displayed, the wounded are scientifically catalogued (*Wounded in the Peninsula Campaign,* p. 52). The images of the bodies of the veterans treated and photographed at the army hospital in Montpelier, Vermont, were carefully cut from their backgrounds and suspended in the grid of Dr. Janes's logbook. Many resemble a child's

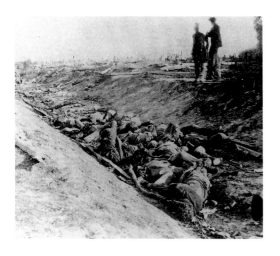

Fig. 5. Dead North Caro-
linians at Bloody Lane at
Antietam

Fig. 7. Scene of General
McPherson's Death

Fig. 6. The Antietam Battle-
field Grave of John Marshall,
from Allegheny City, Penn-
sylvania, Age 50

plastic army men, damaged, clinging to the tuft of ground at their feet (*Wounded at Cedar Creek,* p. 34). Photographs of severed limbs, such as those of amputated feet (p. 110), are horrifying and strange. The assemblage photograph *Results of Wounds* (p. 30) makes evident the new connection between the wounded soldier and his removed bone. Why are these medical photographs absent from Civil War books and picture anthologies?

The exciting structures of modern street photography, figures from foreground to background pulling the viewer into the frame, a suggestion of separate spheres of spontaneous action, are anticipated in Barnard's photograph of the 1st New York Light Artillery at Seven Pines, Virginia (p. 58), although Barnard

obviously set up the picture. Alexander Gardner's photograph of Union soldiers departing from Aquia Creek Landing (p. 124) jumps with the chaotic energy of the war and troop movement. But the picture is highly ordered, a sophisticated extraction from changeable and densely packed forms. An uncertainty of circumstance, actual and pictorial, spins around the travelers.

Dynamic use of the tonal field sets up a pulsating continuum in several photographs of razed cities, most notably that of Richmond in ruins (Fig. 8). The rhythmic distribution of blacks, grays, and whites makes for an edge-to-edge reading of the photograph. There is no center; destruction is everywhere. As indeed it

was in the South in 1865. A large aperture in the lens to produce a short depth of field (only a small part of the photograph rendered sharply) was generally employed to soften the focus of backgrounds. Reversing this norm and blurring the foreground produced some remarkable images. The photograph of a Confederate floating battery (Fig. 9) diminishes humanity and elevates the implements of war by focusing on the cannon in the rear. Using the same technique, O'Sullivan blurs the foliage at the bottom of the frame and injects a portent of approaching chaos into his photograph taken on the day of the battle at Cedar Mountain, Virginia (Fig. 10).

The Civil War field photographers used wooden cameras that held 16" x 20", 8" x 10", or smaller stereographic film plates. The negatives were produced by adhering light-sensitive silver salts onto glass with an emulsion of collodion, a derivative of guncotton, an explosive cellulose nitrate. Positive prints were made by contacting the negative onto paper treated with albumen (egg white and salt) and silver nitrate. The prepared glass plate was overly sensitive to blue,

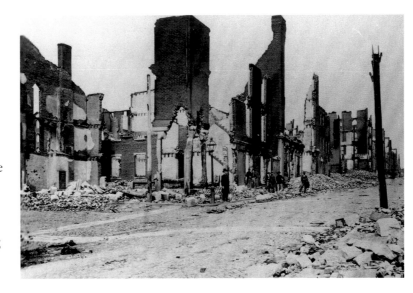

Fig. 8. Richmond in Ruins

13

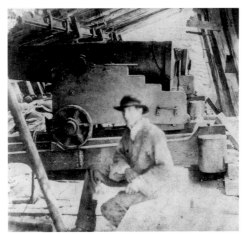

Fig. 9. This Confederate floating battery, moored off Morris Island, fired the first shot against Fort Sumter.

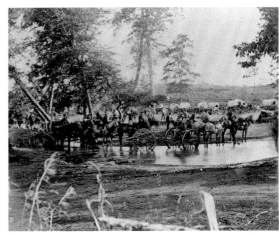

Fig. 10. On the day of the battle at Cedar Mountain, Virginia, 9 August 1862, a Federal battery moves toward the fight.

Fig. 11. Fort Sumter under Union Naval Bombardment on 8 September 1863

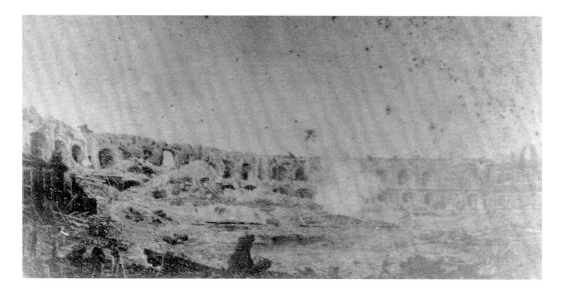

14

meaning that either the sky or the rest of the picture, but not both, could be exposed properly. Overexposed sky and water create a vacuum of Hades around the men and boats in the plate of the USS *Lexington* (p. 72). This wet plate process had other liabilities that were more difficult to overcome. The glass plates had to be coated with light-sensitive chemicals after the camera was set up, and they had to be processed immediately after exposure. Exposure times were long. The fast action of actual battles was virtually impossible to capture. George Cook's photograph of Fort Sumter under Union naval bombardment (Fig. 11), one of the few photographs made during an attack, records the actual explosion of an artillery shell.

Several new genres of photography were pioneered by Civil War photographers. The sequential picture story made an early appearance in *The Federals execute a spy in Mississippi* (Fig. 12). Early examples of a socially concerned photography are the images of ex-slave children in New Bern, North Carolina (p. 128) and Southern refugees (p. 88). These photographs could not be directly printed by halftone in the newspapers or books of the time, but they could be transformed into lower-resolution wood engravings, which could then be printed along with text and widely disseminated. The actual photographs were often distributed as stereo views and sometimes mounted into limited-edition books.

Depictions of the scarred earth, such as Barnard's pictures of the Atlanta campaign (pp.

120, 122), prefigure recent images in American landscape photography. Respect for the earth was not the key motivation of the photographers of the early 1860s, but the disruption of the American pastoral ideal is undeniable. Dead bodies, most of them farmers turned soldiers, litter the fields. Farms and forests were not being used productively; they were being destroyed through the violence of the war. How humanity relates to nature has long been a subject for artists. Since the Civil War, the definition of that relationship has evolved continually and grown in importance.

These early photographs did not belong to the circles of art. They were not examined with regard to their advancement of the medium of photography. Furthermore, due to their painful referent, "we buried them in the recesses of our cabinet as we would have buried the mutilated remains of the dead they too vividly represented," wrote Oliver Wendell Holmes Sr. in 1863 about Mathew Brady's New York exhibition of Antietam photographs ("Doings of the Sunbeam," 12). After 1865 war photographs were put away and often forgotten, damaged,


a spy in Mississippi.

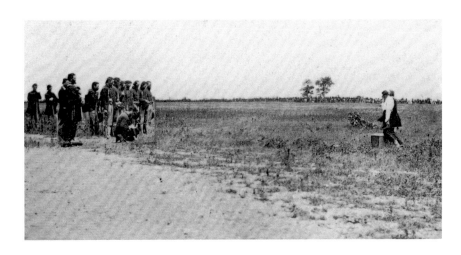

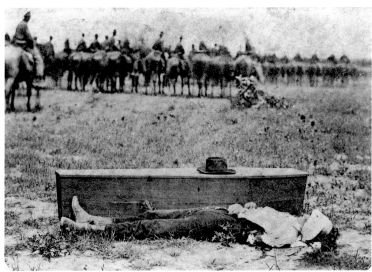

or lost. It is unlikely that many Civil War photographs inspired later imagery of similar form or intent.

A society sustaining a war effort seeks to control or eliminate the imagery of its own dead and wounded. Soldiers are portrayed as brave and cheerful, the systems of supply as efficient, victory as inevitable. In pictorial and verbal descriptions the deaths of soldiers are made palatable by emphasizing glory: they died heroically confronting the enemy, defending the homeland. War is described as destiny, a part of the natural order. The other side is responsible for the horrors. Civil War photographers were certainly aware of these parameters, and because of patriotism or for profit many cooperated. Some photographers, such as Alexander Gardner and Timothy O'Sullivan, were overwhelmed by the actualities of the war and operated on the original premise that to show what they saw would give people a better understanding of the realities of this and other wars. Their belief is still a hope of many war photographers today. Pictures of the dead and wounded are rarely silent, and despite attempts to set them in a political context, they ask, Was it worth it? Was there no other way?

THE PHOTOGRAPHIC PAIRS

In coupling the historical photographs with my own images, I sought wide-ranging connections of culture, politics, economics, and environment. If these conceptual links are supported by formal relationship, all the better. Emotional and physical ties in the pairings were also important. The pairings of photographs and their interchange need not, however, exclude independent readings of either the historical or the modern image.

Both sets of photographs were made by searching for the traces of war. The Civil War photographers were obviously much closer in time to the action of the battle, but with few exceptions they photographed the battlefields after the killing. They too searched for visual material after the action in order to examine what had happened. Proximate in time, they produced dynamic photographs of immediate consequences. Much later in time, I have made photographs more concerned with the long-term results.

The number of extant historical images for battles is extremely variable. The photographic effort increased as the war went on. The battlefields closer to Washington, D.C., a center for several wartime photographic groups, were photographed more completely than those located farther away. The type of coverage also varied considerably, depending on the expectations of the photographer's employer (which might be the army, a private company making views, or individual soldiers) and the sensibilities of the photographer. In the few instances when strong, historical photographs were not available for a particular battle, I used another Civil War photograph, an engraving, or a map. The battlefield maps are distilled, abstract descriptions of killing. They are also linked to the actual development of plans for killing. Their direction in time may be toward the past or the future, but their reality is essentially the same. Mobility, the attack upon the enemy's flank, and attrition were among the most common stratagems of the Civil War. They are portrayed on the maps by, respectively, arrows,

the perpendicular meeting of lines, and static, parallel lines.

The Civil War images inform my photographs. They constitute an eloquent testimony of the participants and the events. They shade the modern picture with a complex but specific historical context. Viewed apart, my photographs can be seen as a somewhat random sampling of the state of the contemporary American landscape. Where the armies or companies of soldiers happened to meet to kill each other depended on such a wide assortment of factors, including chance, that I could have been throwing darts into maps to determine where I would photograph. We often view landscapes within an implicit context of geological evolution and time. The landscapes of today and those of the Civil War add the crucial modern context of human use.

The current conditions of the battlefields embody our dispositions toward the environment. Indicative of the entire country, these attitudes range from total disregard to real appreciation of natural systems. I found the widespread dispersion of garbage to be incred-

ible. Styrofoam cups, hamburger containers, and packing peanuts are literally everywhere. Some battlefields have even more serious forms of pollution. Others have simply been leveled to create more space for shopping.

In a culture with pronounced respect for military endeavor the expedient treatment of these battlefields does not bode well for lands that have no claim to the special status of "sacred ground." While many battlefields face these types of problems, others are dealing with an opposite situation. In some of the large national parks, such as Manassas and Vicksburg, large areas are returning to thick forest. These trees were not present during the fighting—either the battlegrounds were fields to begin with or the trees had been cut down by the armies—and the foliage can make it difficult to visualize the events of the combat. The trees signify a return of peace to the killing ground, but they also remove the signs of violence against which we value that peace.

My photographs inform the reading of the Civil War photographs also. The modern pictures may be seen as consequences of, and

reflections upon, the acts of the Civil War soldiers. Today we may stand on a battlefield and imagine what happened and its effects, just as some Northern and Southern soldiers may have stood on the same ground, before or after the fighting, and wondered how they were affecting the future. This was, after all, an intention in going to war: to shape history, to extend their side's version of manifest destiny.

American landscape photographs inevitably become involved with the fantasies of America. The shock of having access to a sparsely populated, naturally rich expanse of land generated a hubris of opportunity and destiny in early Americans that, despite the realization of its consequences, still echoes in our psyches. From its inception in the 1860s to the 1960s, American landscape photography (and much painting as well) has been dedicated largely to showing the great natural glories of the American landscape. We are deeply connected to these images. They are bigger than ourselves. They seem to possess a time greater than our own, suggesting eternal values. Through looking at these images we have come to believe in the infinite extension and promise of the American wilderness. Like our predecessors, we can thrill to God's blessings upon this American land and the possibilities of human action upon such "undefined" territory. Innate human hopes and needs have been focused upon the land and its image.

Landscape photography has become much more than natural content or formal relation-

ship. Archetypal human desires for freedom and a new beginning, and the American social ethics of individualism, a can-do mentality, material progress, and belief in our system and its extension to the rest of the world, have been associated with the beauty of the landscape. The pervasive coupling of landscape imagery with these psychological and political contents means that almost any photograph of the American land comments on this American myth. As we realize these linkages, however, we can go beyond them and make connections to the landscape that may still be spiritually freeing but will be more responsible to human and other forms of life. The recognition of the inherent connection between the landscape and ourselves ultimately provides more freedom. America's landscapes are no longer eternal and unchanging. They have become provisional. Signs of our presence are visible everywhere. Human decisions now largely determine the condition of the landscape.

A strange combination of clarity and fear takes hold when new violence occurs on an old battlefield. While photographing at the Salem Church at Chancellorsville, Virginia, I heard a loud crash behind me and turned to see an automobile accident just twenty yards away. My mind had been drifting; it became immediately grounded. A stunned older woman sat behind the steering wheel of a car smashed from behind by a young man who was cursing and pounding the steering wheel of his sporty vehicle. Rush-hour traffic out of Fredericksburg immediately backed up; hundreds of angry people were closed up in their immobile cars. The rescue vehicles had difficulty getting through.

I had the camera set up at Ivy Mountain in Kentucky when I noticed a scruffy old dog trying to cross the dangerous four-lane highway. He made a couple of starts, turning back just before he would have been hit. With a sickening feeling of knowing what was going to happen, I watched as he tried again and was hit immediately by a car traveling about 60 miles per hour. With a yelp he was pulled under the car and dragged along for forty yards before rolling out from under the back. He lay still for a moment, then got up and limped across the road, to almost be hit again.

The Yellow Bayou battlefield in Louisiana is remote and beautiful. I had the camera set up a little off the road when a pickup truck passed by; the guy on the passenger side was screaming curses at me. He seemed to be struggling to get out of the window, like a vicious dog. I retreated closer to the woods. A few young men skulked behind the trees. As I was trying to return to the past violence of the Civil War, another pickup truck, with two rifles in the gun rack, veered off the road and drove straight across the brush toward me. These men were from the Louisiana State Penitentiary. They warned me that "three violent Cubans have escaped from the detention center nearby. We just caught one down the road. The other two are still at large. Watch out."

A few months later I prepared for a longer trip in Louisiana that would involve a number of nights camping out. I debated whether I should carry my pistol. I finally decided against it and had a trip marked with hospitable welcome from strangers.

Some veterans describe their war experience as the time of their life when they felt most alive. When everything is on the line, the senses become sharply focused. Good art also evokes intense mental and sensual clarity, and it probably will not kill you.

It is my hope that this book will counter the tendency to romanticize war; unfortunately, however, the greatest leveler of notions of glory is direct acquaintance with the facts of war itself. Years ago I worked on a swing scaffold high above the streets of Detroit with a Vietnam veteran. He told me, "I will never, never, fight in another war unless the enemy is actually on my doorstep." Most Americans would not sympathize with this attitude, but most Americans did not serve in that excruciating conflict. Professional soldiers are undoubtedly more prepared for war than the rest of us, but they are no more willing to go. They know the realities. The reasonable prerequisites

to war—exhaustion of alternatives, clarity of objectives, and clear domestic support—are now advocated by the U.S. military as much as they are by anyone.

Describing and understanding the United States is no simple task. Not only is the nation a complex array of geographies, peoples, and systems but our judgments are clouded by a charged and variant mythology. America as idea oscillates between visions of grandeur and visions of disillusion. Can we acknowledge and balance these conceptions as we look at our country? Perhaps the best approach is similar to looking at and connecting the photographs of past and present in this book. The truth will come from an equilibrium of perspectives.

I began this writing by speaking of regional attachment. Clearly, that is where we begin—with our neighbors and our local environment. But the Civil War has given us a larger context, connecting us with our countrymen in the Bronx and our land in southern California. Unification has put in place social and economic structures that can be overwhelming in terms of their size and complexity. Alienation and confusion, fear and cynicism, are often the results. But American culture is rich in its different peoples and terrains and in the exchange of ideas. The legacy of the Civil War

is the belief that such diversity means a stronger, better society. We are discovering that a parallel diversity in the environment makes our earth more vibrant and resilient. Out of terrible and complicated circumstance, the Civil War has bequeathed us a larger vision of our nation, one that can only work with a concurrent expansion of tolerance. Inclusion in American society need not mean conformity. Ultimately such tolerance means an end to the pain of war.

Americans have continually embraced new ways of doing things. Our predecessors invented and reinvented our country. The challenge is still with us: to create a new society based on true equality—in education, in the safety of the neighborhood—in which all things are indeed possible, for all people. In moving toward the new we cannot forget the past, of greed and racism but also of the Constitution and the Bill of Rights and the sacrifices made in the Civil War for democratic ideals. The relation between whites and blacks is the acid test of America's ideals. True acceptance of colored peoples into American society means a

new society and a stronger union, based on the encounter between different experiences.

Tolerance in its broadest and most positive sense is education—the straightforward introduction, examination, and free flow of new information, experiences, and ideas. Education is the basis for democracy and has engendered our success. All Americans must have access to a vital education. Only then can we go beyond the "triumph of economics" and make decisions based on the deeper values of existence.

As we struggle for a better American society, we recognize that our good fortune and strength give us the responsibility to act on behalf of those people around the world who are mired in circumstances of severe poverty and repressive governments. Since the reunification of the United States 137 years ago we have come to recognize that the earth itself is a fundamental unity. The photographs of our planet from space are beacons to be held close to the heart as we enter the new millennium. We must export the best of America, not Coca Cola, and import the best of the world, not ATVs. Surely we have amassed enough materi-als. Now is the time to share our prosperity and move on to an understanding of what really makes life worth living. Elevation of the spirit of humankind is the great challenge now facing America.

The United States of America has had two beginnings. The Revolution created a nation without precedent in human history, a nation based on individual freedoms with provisions for a government that would serve the people. The Civil War affirmed the principles of the Revolution but went beyond individual and regional concerns to insist upon the fundamental unity of the nation. *Indivisible* was now written in so much blood that American destiny was seen in terms of the collective. Our current situation calls for another beginning, one in which the country will continue to strive for the great principles of the Revolution and the Civil War but also will form new directions in this new world—a political process less beholden to campaign finance, a long-term perspective and planning, an affirmation of our place in the world, meaning apart from materialism, change without war.

We have emerged from the killing ground of the Civil War with a longing for a lasting peace in a just society. To touch the killing ground is to remember this fervent desire. To honor the sacrifice of North and South is to temper our pessimism with renewed hope in the promise of the United States of America.

THE PLATES

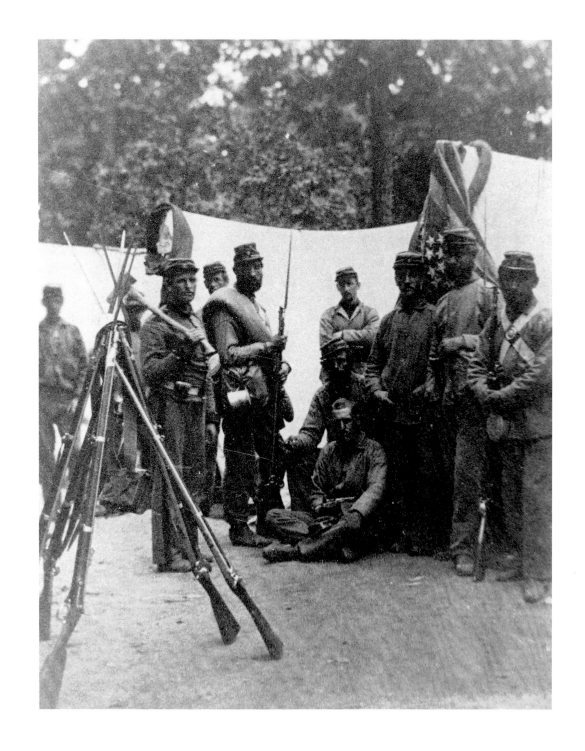

21 July 1861

FIRST MANASSAS, VIRGINIA

Union Trainees of the 8th New York State
Militia Prepared for the March to Manassas

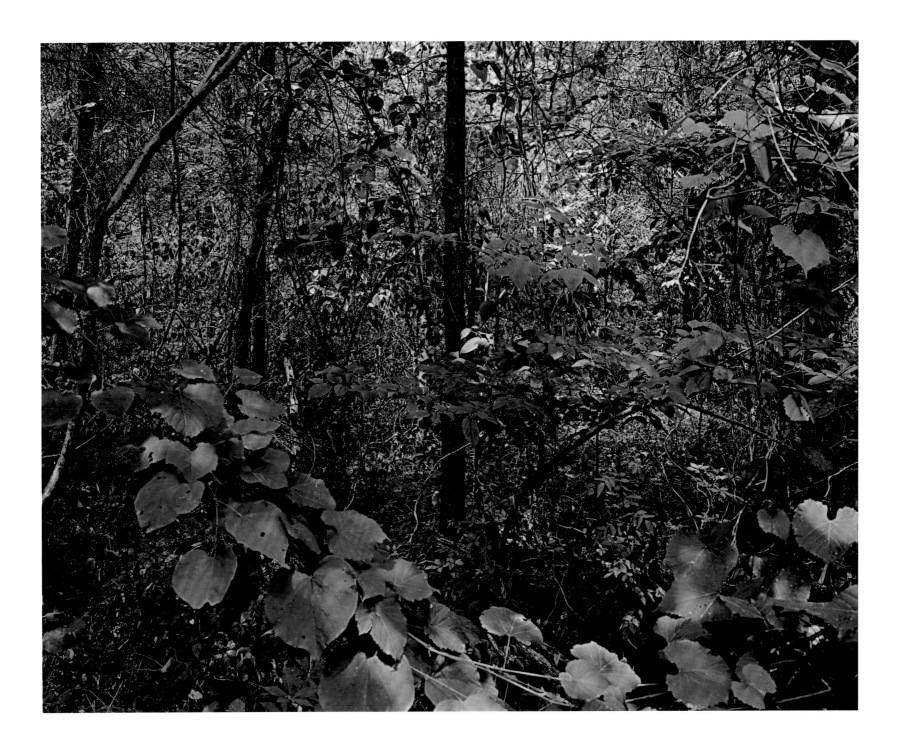

FIRST MANASSAS, VIRGINIA Matthews' Hill, Scene of a Critical
Confederate Delaying Action

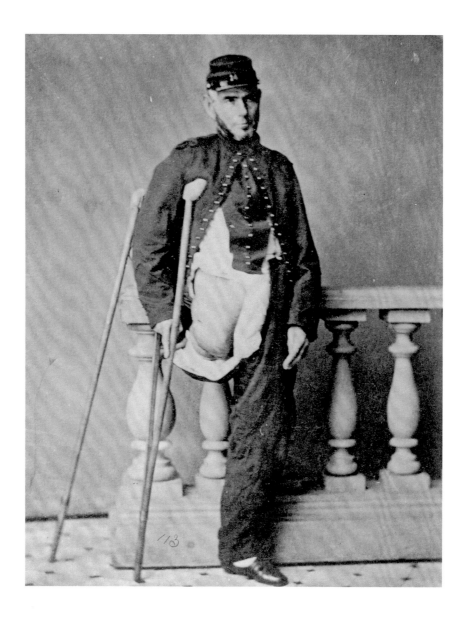

FIRST MANASSAS, VIRGINIA Lewis Francis, age 42, of Brooklyn, New York, had his leg amputated after a bayonet
thrust opened his right knee. He was bedridden until his death in 1874 at age 55.

4,878 American Casualties Bull Run Skirmish Area

FIRST MANASSAS, VIRGINIA

7 November 1863 Site of the Confederate Center

RAPPAHANNOCK STATION, VIRGINIA

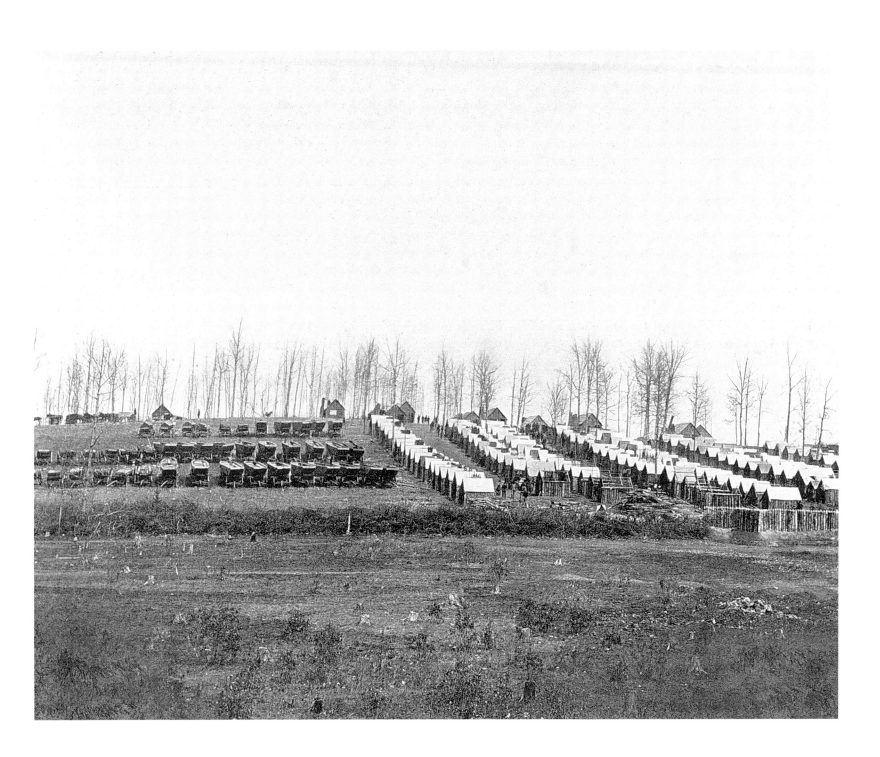

2,049 American Casualties

RAPPAHANNOCK STATION, VIRGINIA

After the battle, Union engineers made
their camp here.

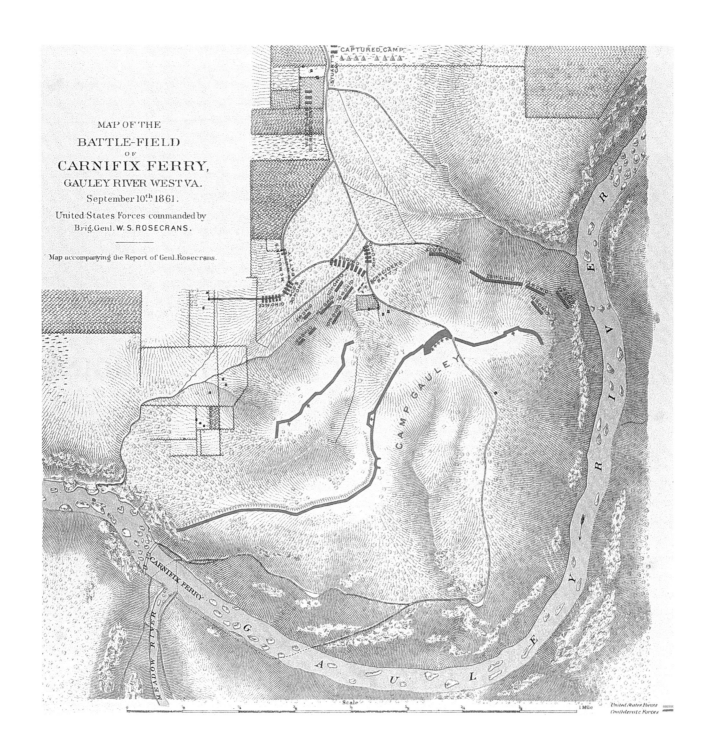

MAP OF THE
BATTLE-FIELD
OF
CARNIFIX FERRY,
GAULEY RIVER WEST VA.
September 10th 1861.

United States Forces commanded by
Brig.Genl. W. S. ROSECRANS.

Map accompanying the Report of Genl. Rosecrans.

10 September 1861
CARNIFIX FERRY, WESTERN VIRGINIA

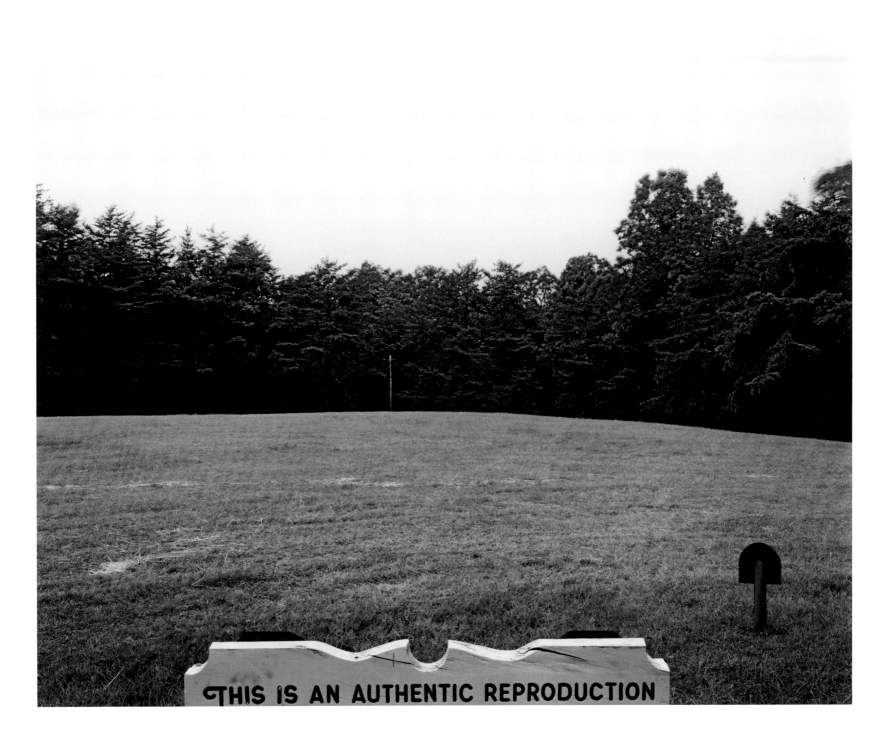

THIS IS AN AUTHENTIC REPRODUCTION

178 American Casualties Site of the Union Right Flank

CARNIFIX FERRY, WESTERN VIRGINIA

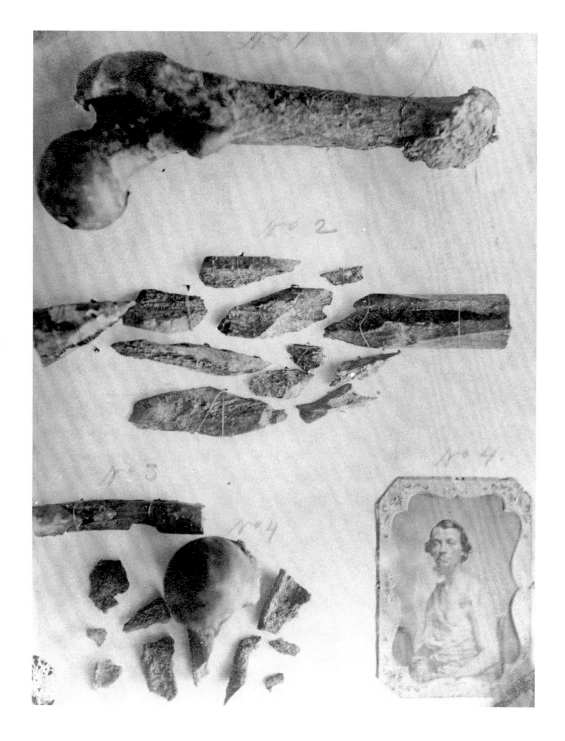

Results of Wounds: Parts of the Thighbone of C. W. Dwyer, of Maryland, and Bone
Fragments from the Arm of Soldier LaRock (Shown after Recovery)

5 May 1862

3,928 American Casualties

Just South of Fort Magruder, Scene of Attack and Counterattack

WILLIAMSBURG, VIRGINIA

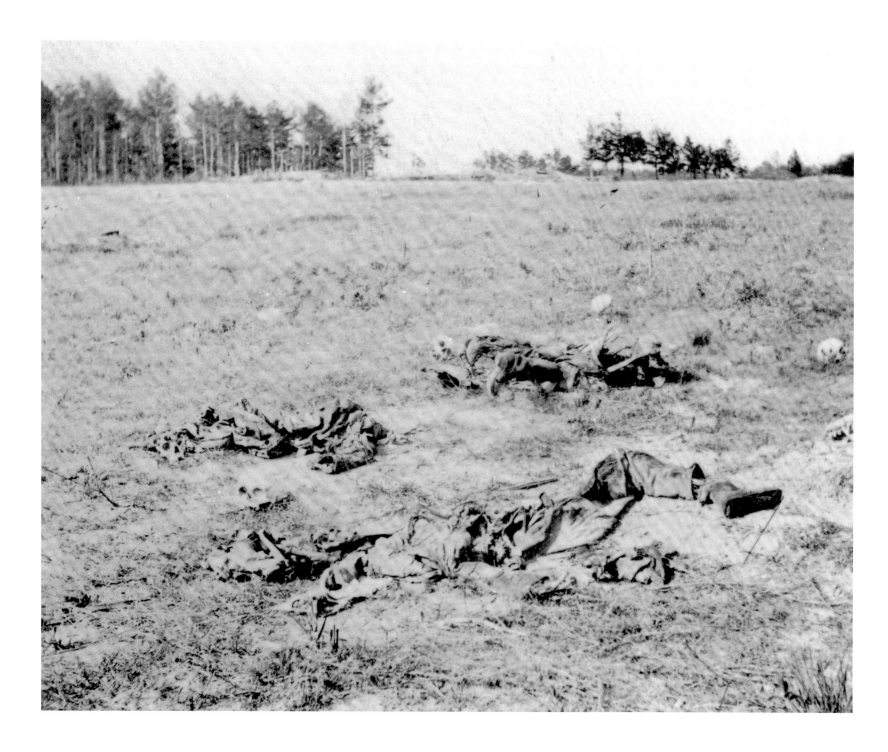

27 June 1862
GAINES' MILL, VIRGINIA

Federal dead from Gaines' Mill were photographed in 1865 after their shallow graves had been exposed.

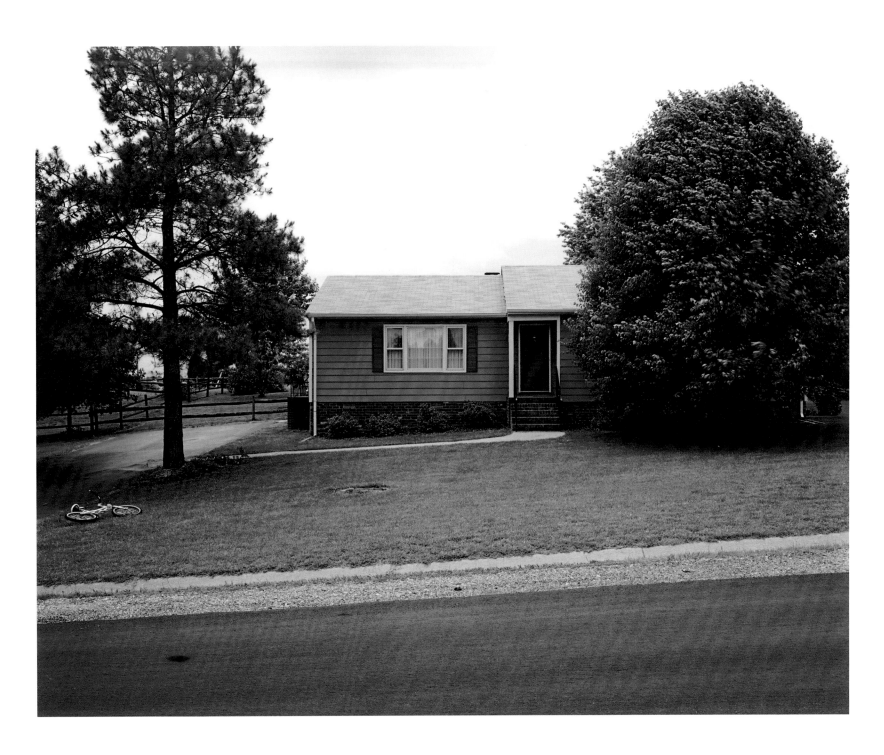

15,587 American Casualties

GAINES' MILL, VIRGINIA

Center of the Battle Lines, Site of Several
Unsuccessful Confederate Charges

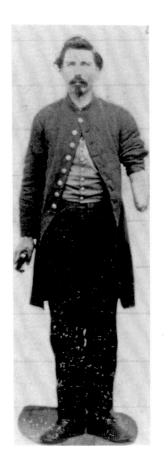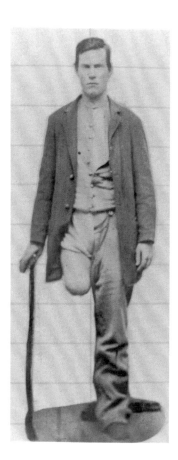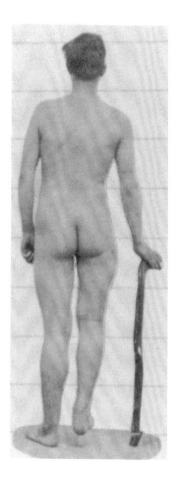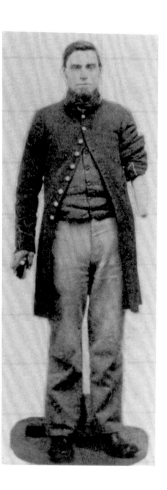

19 October 1864

CEDAR CREEK, VIRGINIA

Wounded at Cedar Creek: Lelah Holbrook, Whitingham, Vermont, Age 21; Marshall Hatch, East Hardwick, Vermont, Age 25; Rufus Pray, Vermont; William Griffin, Granby, Vermont, Age 22

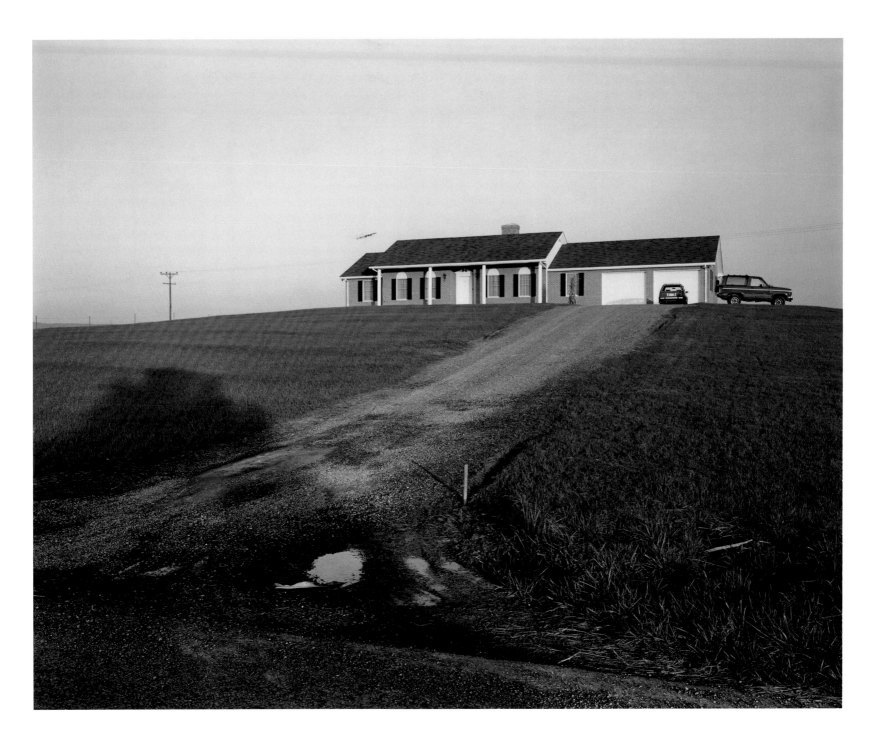

8,575 American Casualties

CEDAR CREEK, VIRGINIA

Here the Confederates broke the hastily formed Union line shortly before noon. The Federals successfully counterattacked over this same ground that afternoon.

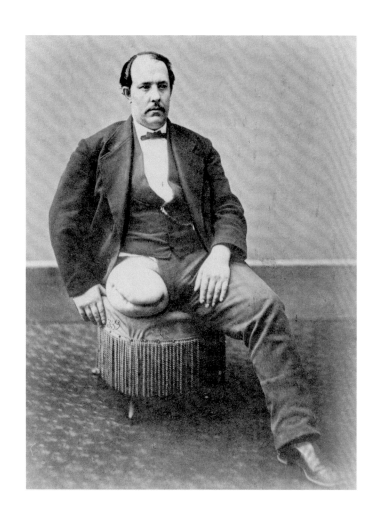

36

1 September 1862
CHANTILLY, VIRGINIA

Wounded at Chantilly: Lorenzo E. Dickey,
of Maine, Age 21

2,100 American Casualties

CHANTILLY, VIRGINIA

The Confederate center received the first
Union charge here.

15 June 1864–2 April 1865 Site of Fort Sedgwick

PETERSBURG, VIRGINIA

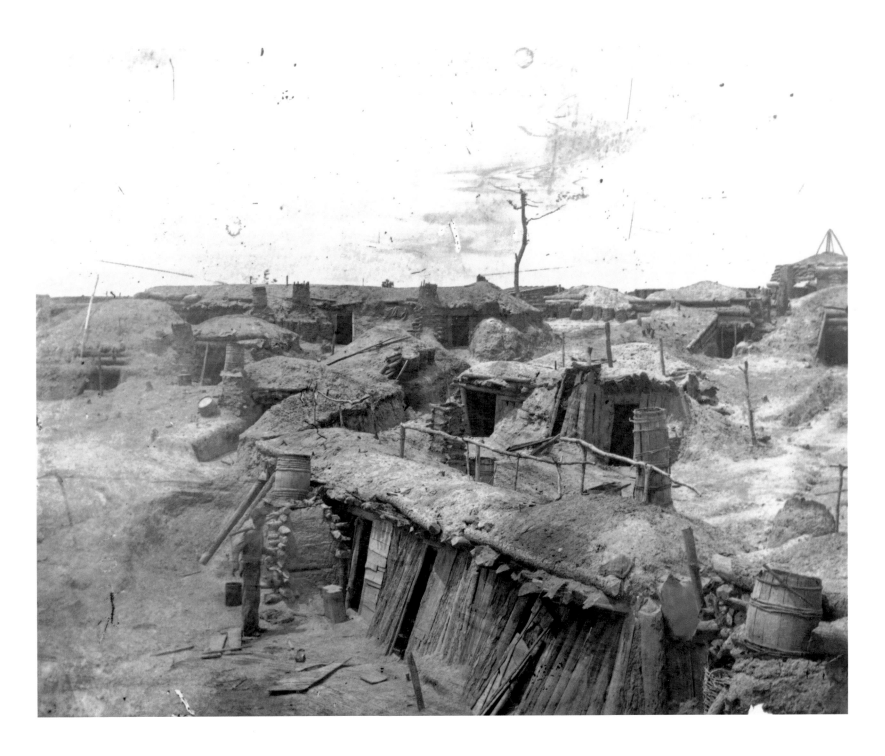

70,000 American Casualties

PETERSBURG, VIRGINIA

Bombproof Quarters of Fort Sedgwick, a Key
Position on the Eastern Union Siege Line

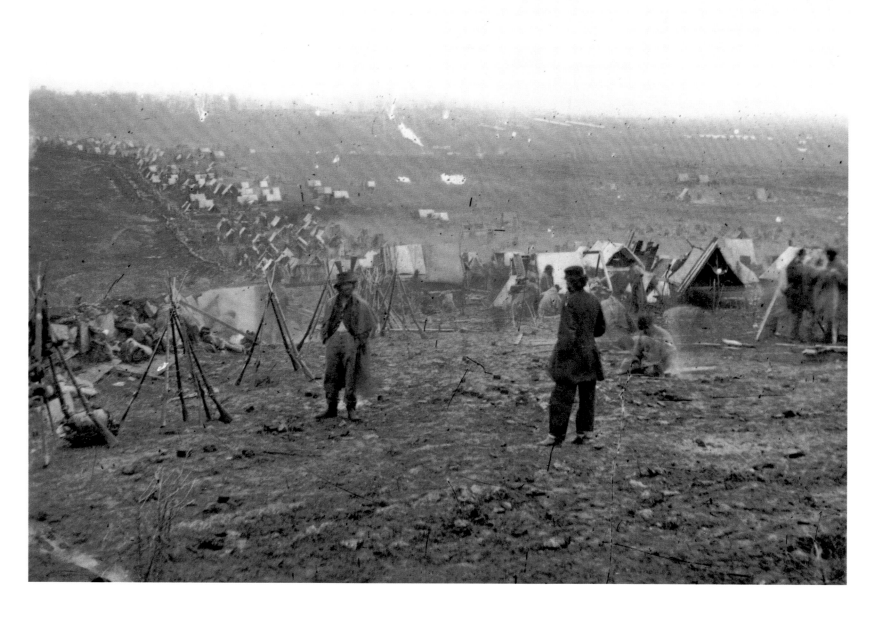

15–16 December 1864

NASHVILLE, TENNESSEE

Union Defensive Line at Nashville on the
Second Day of the Battle

7,407 American Casualties

NASHVILLE, TENNESSEE

Site of the Union Attack on the
Confederate Left

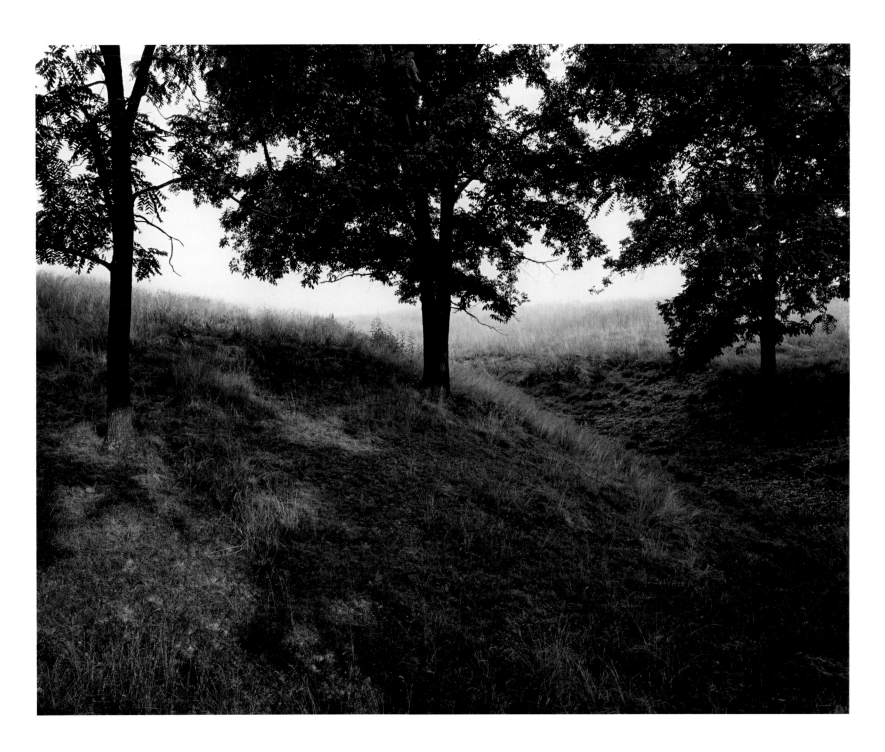

8 June 1862

897 American Casualties

On the Confederate Right

CROSS KEYS, VIRGINIA

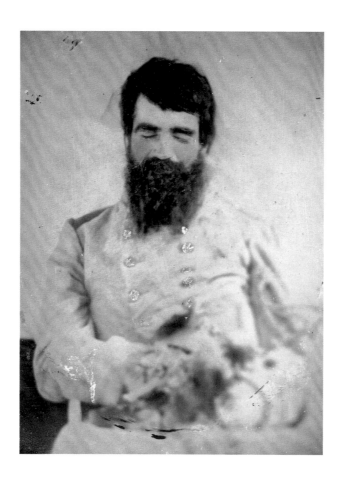

44

6 June 1862

HARRISONBURG, VIRGINIA

Turner Ashby, of Fauquier City, Virginia, age 33, was photographed after being killed here.

130 American Casualties The Center of the Battlefield

HARRISONBURG, VIRGINIA

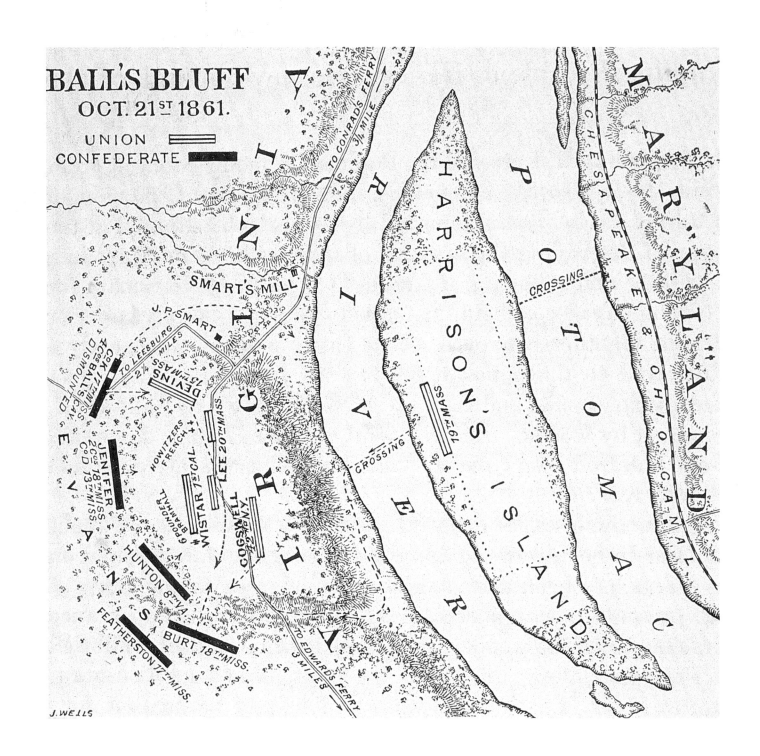

BALL'S BLUFF
OCT. 21ST 1861.

UNION
CONFEDERATE

TO CONRADS FERRY
¾ MILE

MARYLAND

CHESAPEAKE & OHIO CANAL

POTOMAC

CROSSING

HARRISON'S ISLAND

79TH MASS.

CROSSING

VIRGINIA

RIVER

SMART'S MILL

J. P. SMART

TO LEESBURG
2½ MILES

DEVINS
15TH MASS.

CK 17TH MISS.
DISMOUNTED
4 CO 8TH VA.

LEE 20TH MASS.

JENIFER
2 CO 18TH MISS.
CO D 13TH MISS.

HOWITZERS
FRENCH

6 POUNDER
BRAMHALL

WISTAR 71ST CAL.

COGSWELL
42 N.Y.

HUNTON 8TH

FEATHERSTON 77TH MISS.

BURT 18TH MISS.

TO EDWARDS FERRY
3 MILES

J. WELLS

21 October 1861
BALL'S BLUFF, VIRGINIA

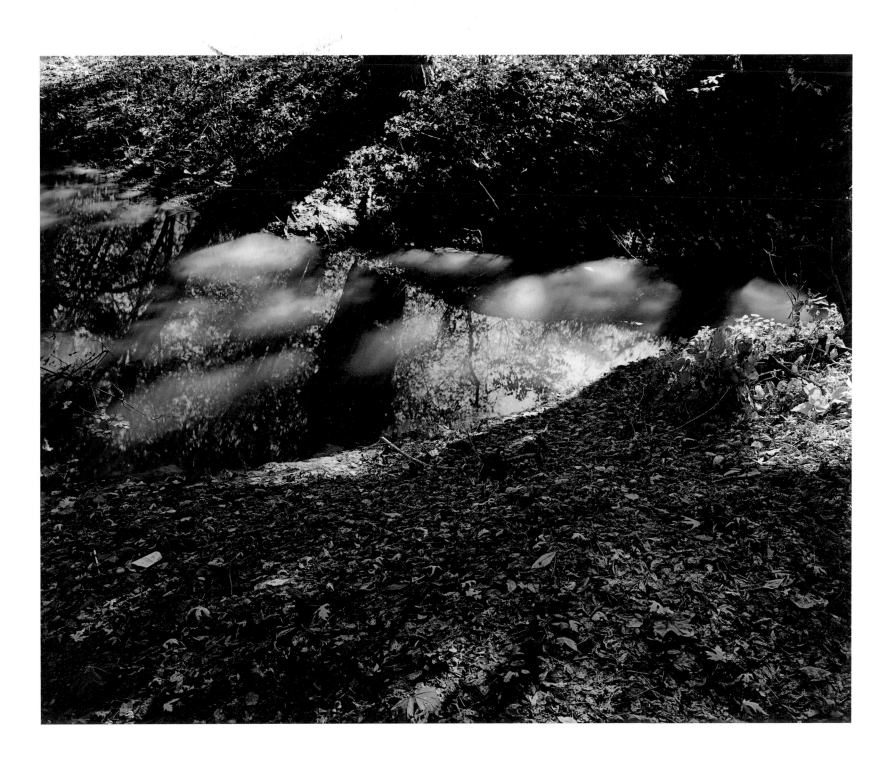

1,070 American Casualties

At the Base of the Bluff

BALL'S BLUFF, VIRGINIA

18–28 April 1862

FORT JACKSON, LOUISIANA

Cannon Position within the Confederate
Fort, Center of the River Facade

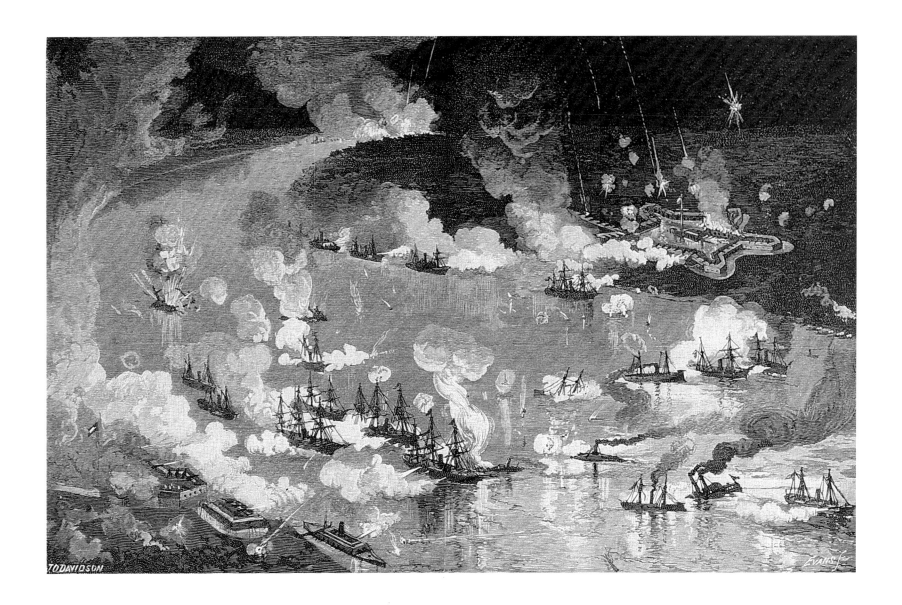

1,011 American Casualties

FORT JACKSON, LOUISIANA

The Federal Fleet Engaged with the
Confederates, 4:15 A.M., 24 April 1862

19 September 1864 Creek Daniel McIntosh and Cherokee Stand Watie led the Confederate Indian Brigade.

SECOND CABIN CREEK, CHEROKEE NATION, INDIAN TERRITORY

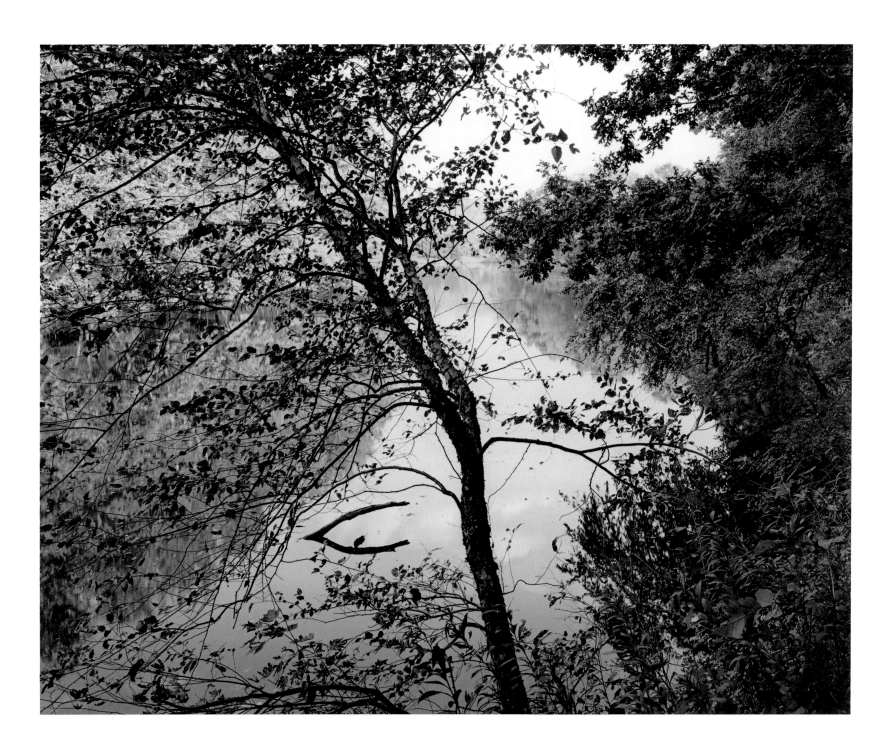

130 American Casualties The last Union position was on the left bank of the once fordable stream.

SECOND CABIN CREEK, CHEROKEE NATION, INDIAN TERRITORY

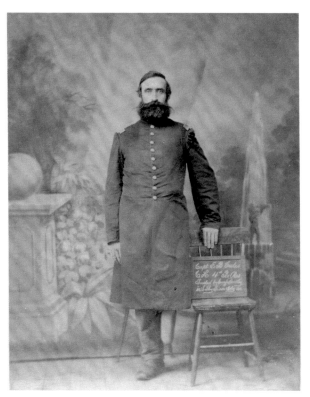
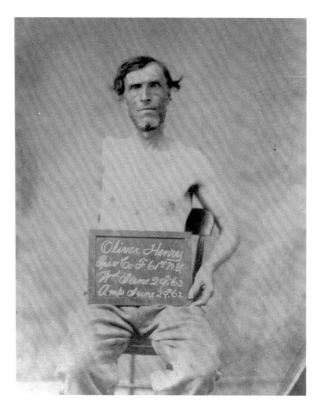

26 June 1862

MECHANICSVILLE, VIRGINIA

Wounded in the Peninsula Campaign: Thomas Lenihan of New York, E. B. Gates of
Pennsylvania, and Oliver Henry of New York

1,845 American Casualties

Beaver Dam Creek was the site of a failed
Confederate charge.

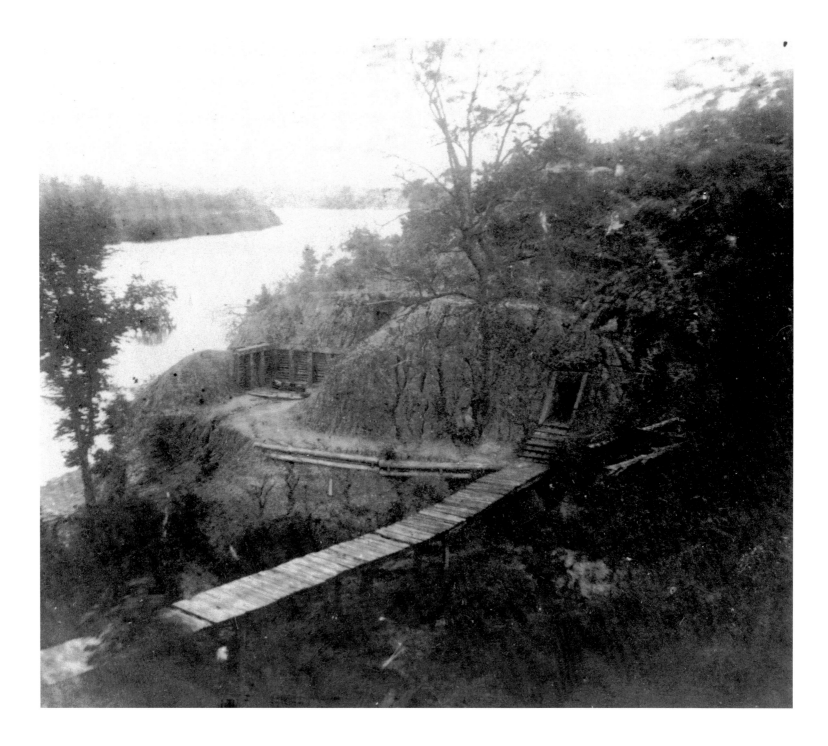

15 May 1862 The Confederate Fort

DREWRY'S BLUFF, VIRGINIA

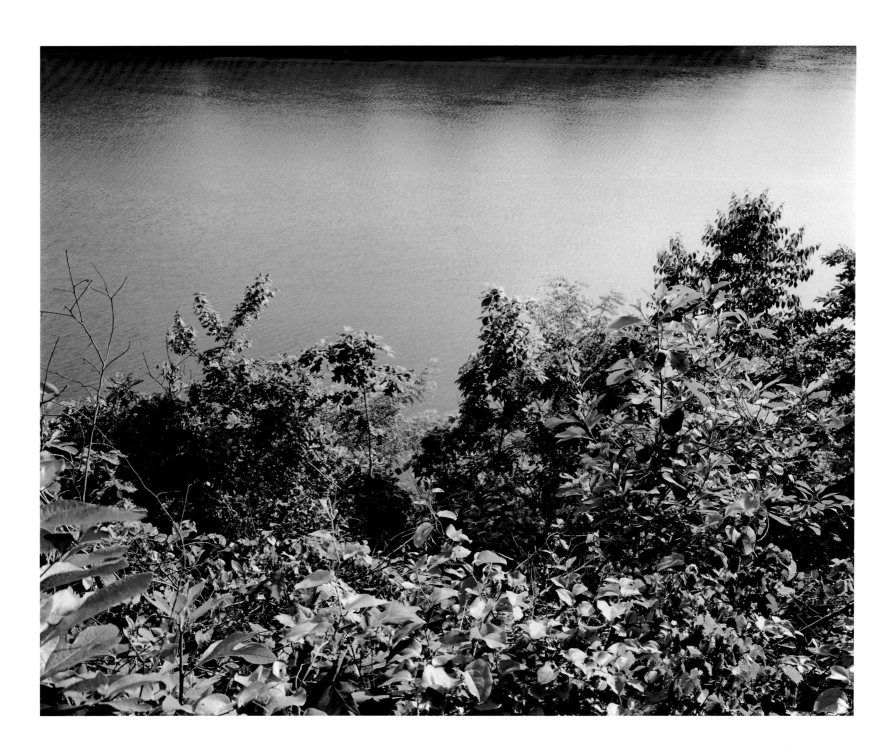

41 American Casualties

DREWRY'S BLUFF, VIRGINIA

View from a Confederate Gun

Emplacement on the James River

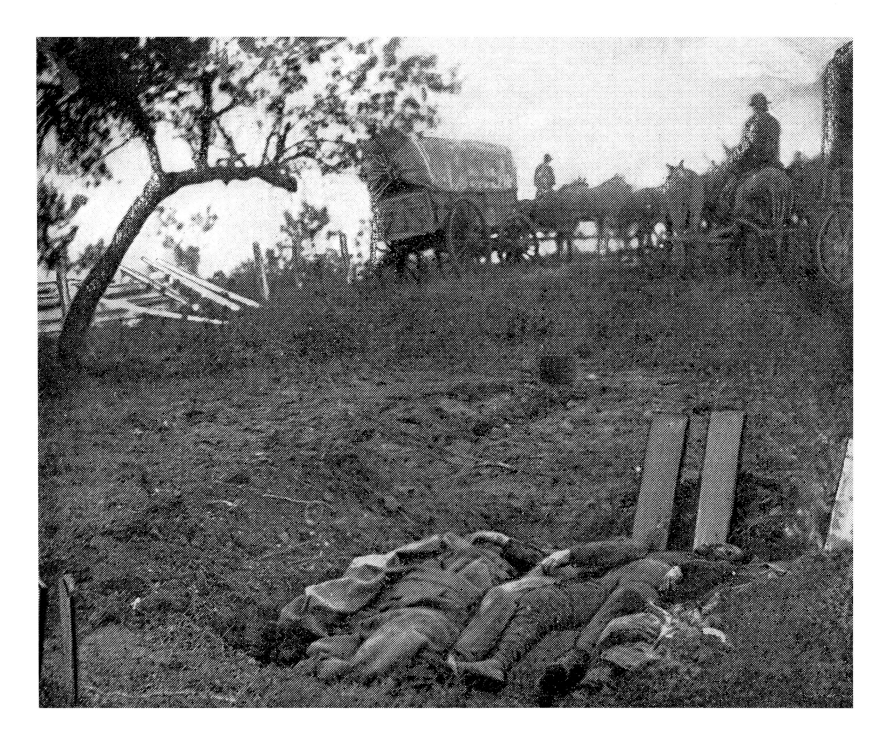

Soldiers' Burial near the Rose Farm on the
Battlefield at Gettysburg, Pennsylvania

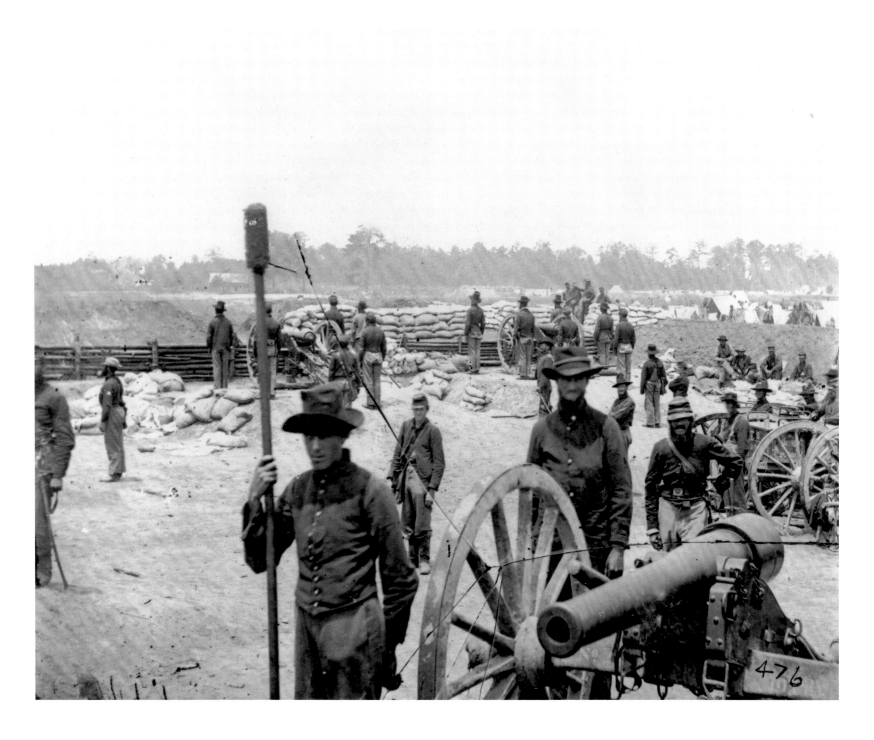

31 May 1862 1st New York Light Artillery at Seven Pines

SEVEN PINES, VIRGINIA

11,165 American Casualties

SEVEN PINES, VIRGINIA

Site of the Union Right Flank Early in
the Battle

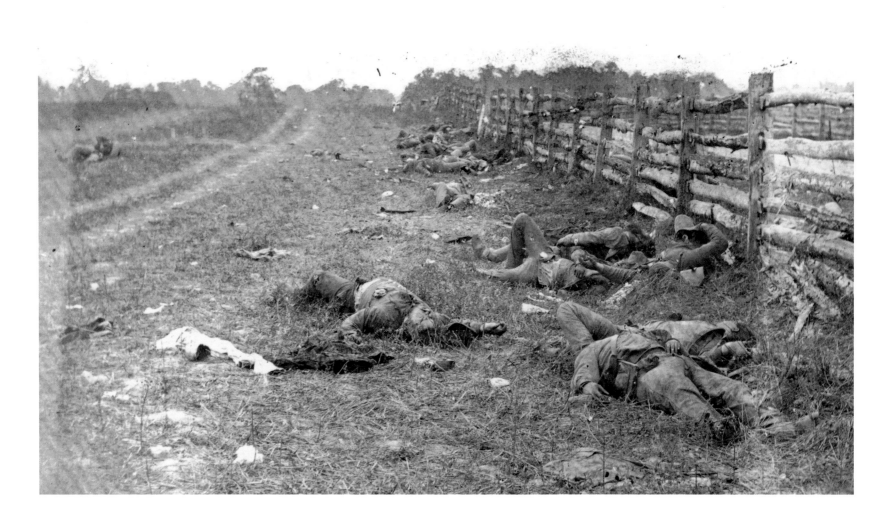

17 September 1862 The Dead near the Cornfield

ANTIETAM, MARYLAND

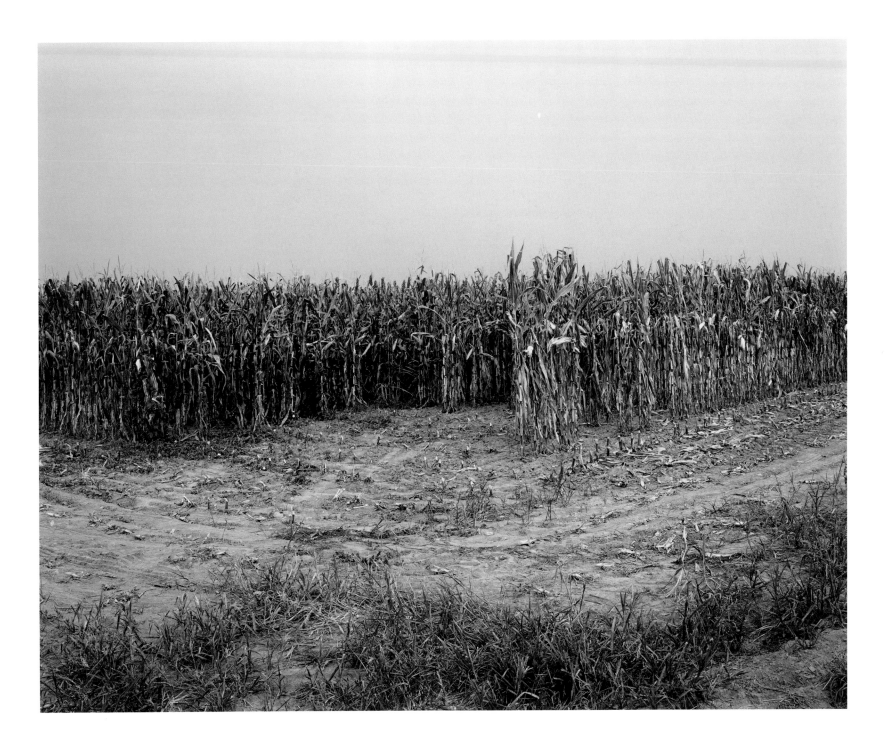

ANTIETAM, MARYLAND

The Cornfield. The morning's intense shooting reduced the
entire forty acres of ripe corn to stubble a few inches high.

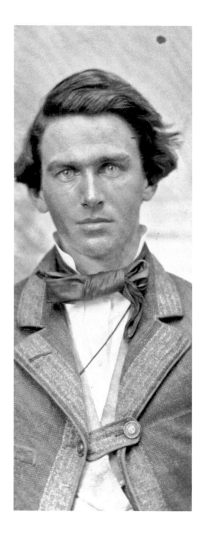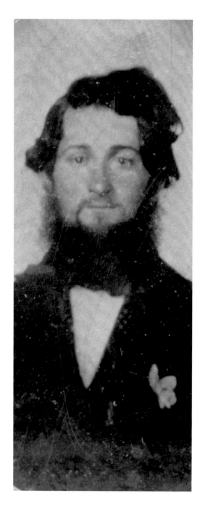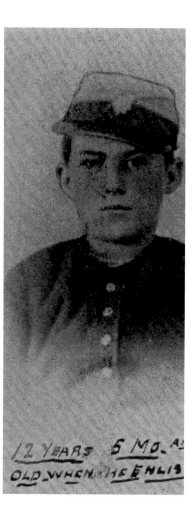

Killed at Antietam: Thomas Rushin, Buena Vista, Georgia, Age 25; John Clark, Monroe, Michigan, Age 21; William Parran, Barboursville, Western Virginia, Age 29; and Charley King, West Chester, Pennsylvania, Age 13

26,193 American Casualties

ANTIETAM, MARYLAND

Antietam Creek, Just below Burnside Bridge

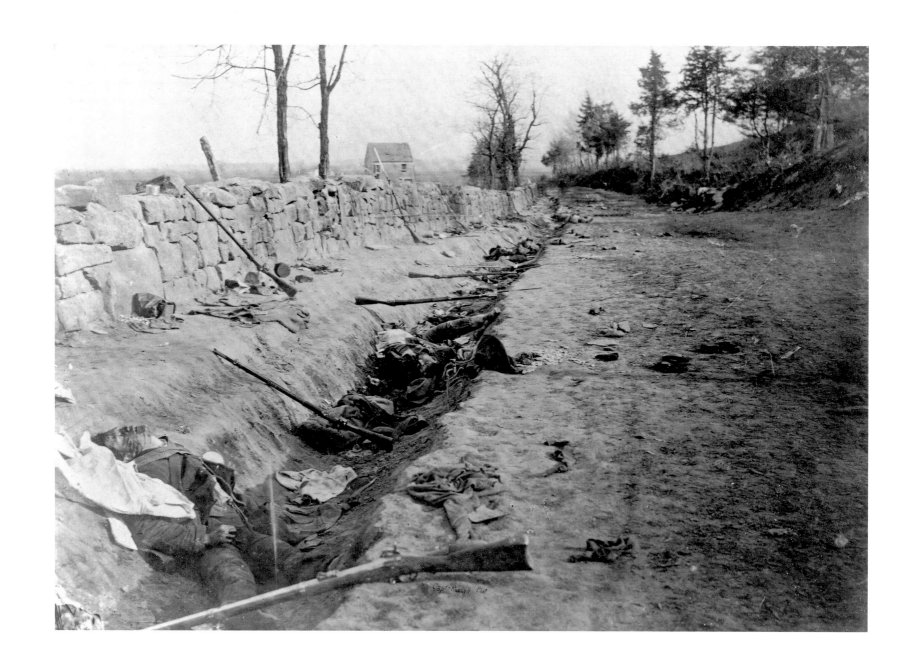

1–4 May 1863

CHANCELLORSVILLE, VIRGINIA

This Confederate position below Marye's Heights was
photographed within a half-hour of their retreat.

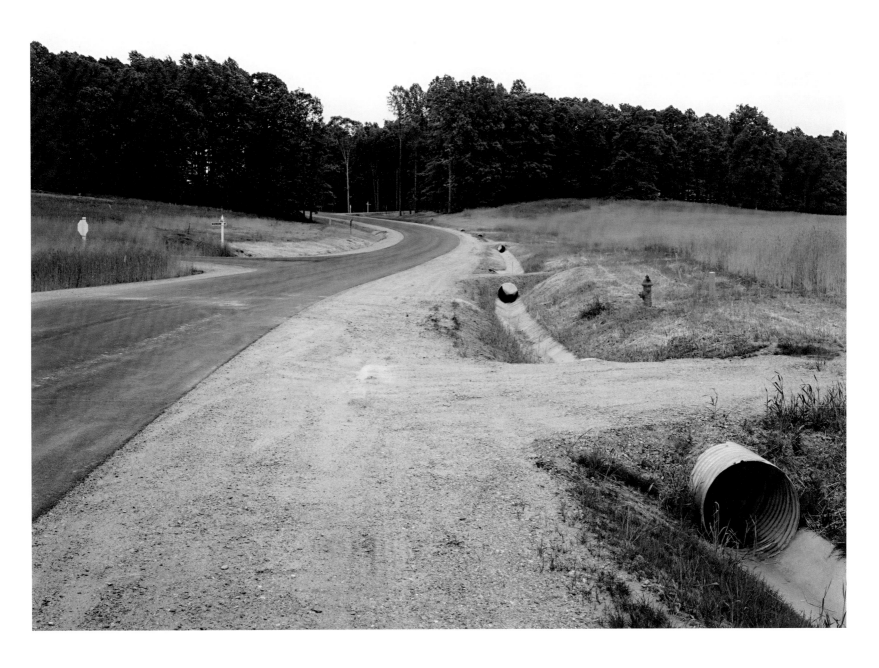

30,051 American Casualties

CHANCELLORSVILLE, VIRGINIA

The first contact between the armies occurred here, where a
housing development will soon be built.

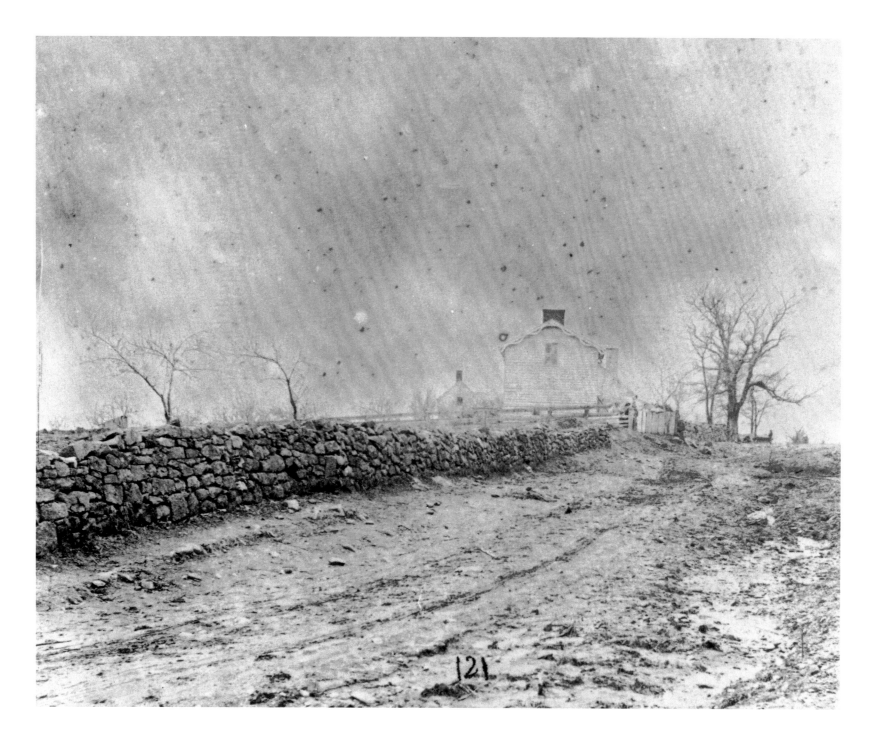

121

13 December 1862

Confederate Position on Marye's Heights

FREDERICKSBURG, VIRGINIA

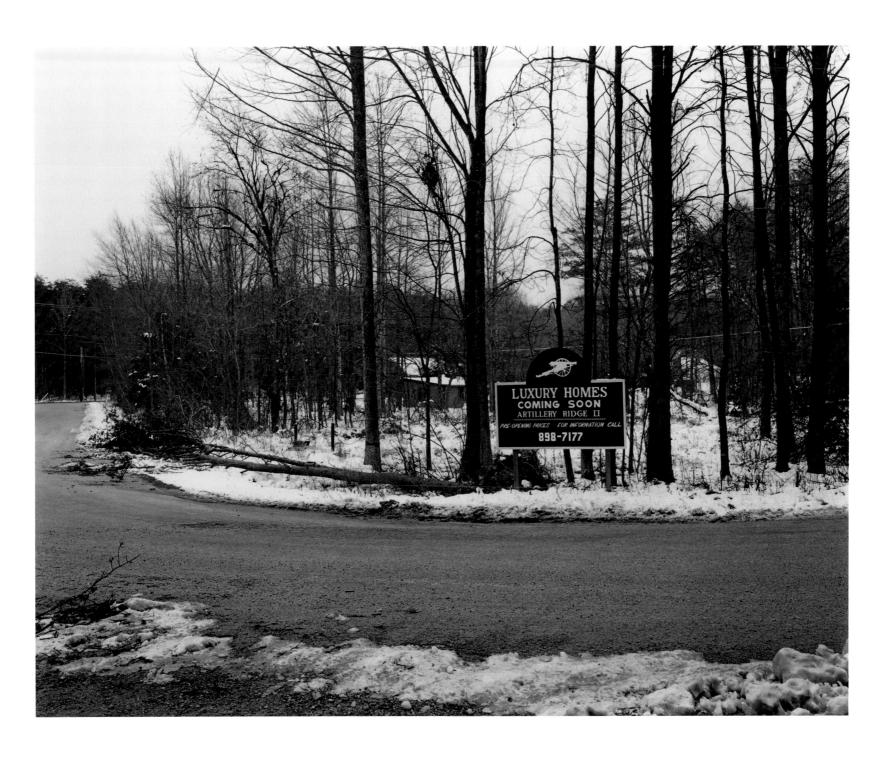

17,962 American Casualties The Middle of the Confederate Line

FREDERICKSBURG, VIRGINIA

View from the Union Position at the Hornets' Nest. An isolated pocket of Northern soldiers withstood eleven Confederate charges across this field before surrendering, Shiloh, Tennessee.

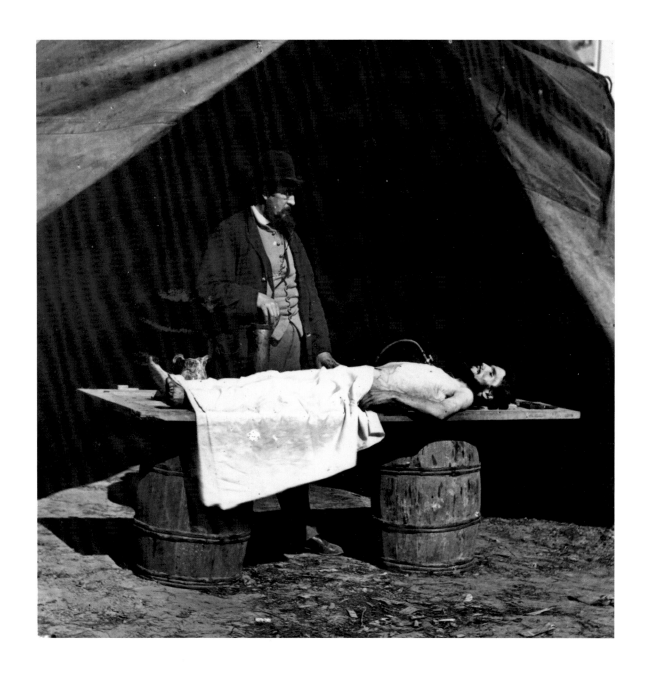

70 Richard Burr, M.D., Embalming Surgeon
of the Army of the Potomac

11–13 September 1861

281 American Casualties

Inside the Union Fort, Now a Closed Strip Mine

CHEAT MOUNTAIN, WESTERN VIRGINIA

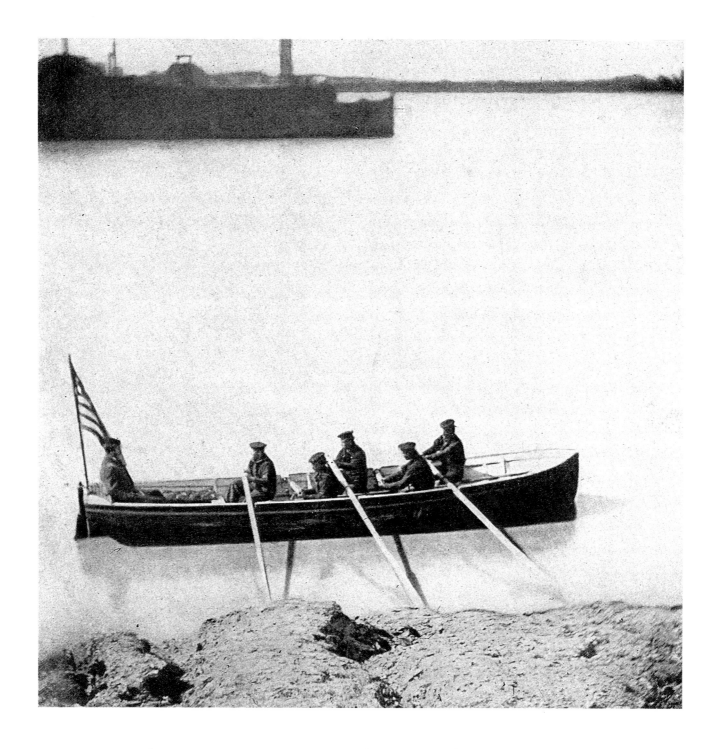

6–7 April 1862

SHILOH, TENNESSEE

The guns of the USS *Lexington* (background) shelled the Confederates throughout the evening and night of 6 April.

23,746 American Casualties

SHILOH, TENNESSEE

Bloody Pond. Here the wounded from both sides dragged themselves to drink and to die.

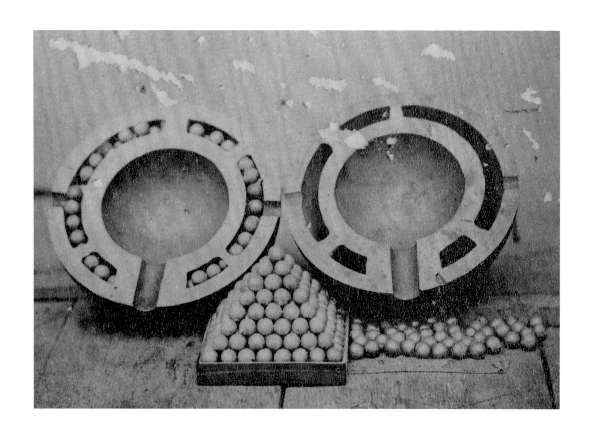

Exploding Antipersonnel Cannonball

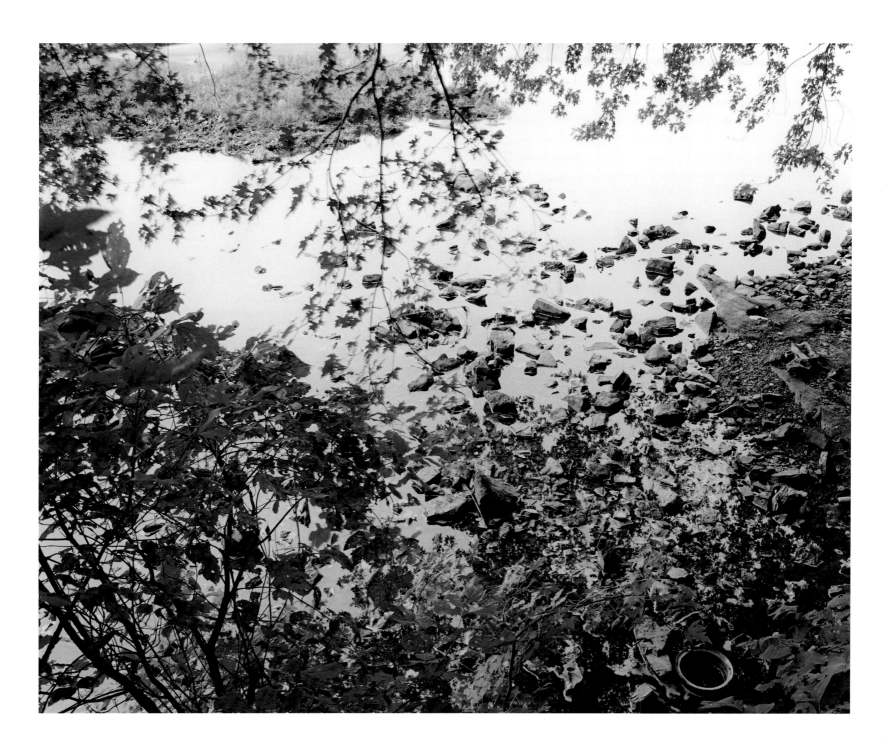

20 September 1862 The Ford on the Potomac River

590 American Casualties CEMENT MILL, WESTERN VIRGINIA

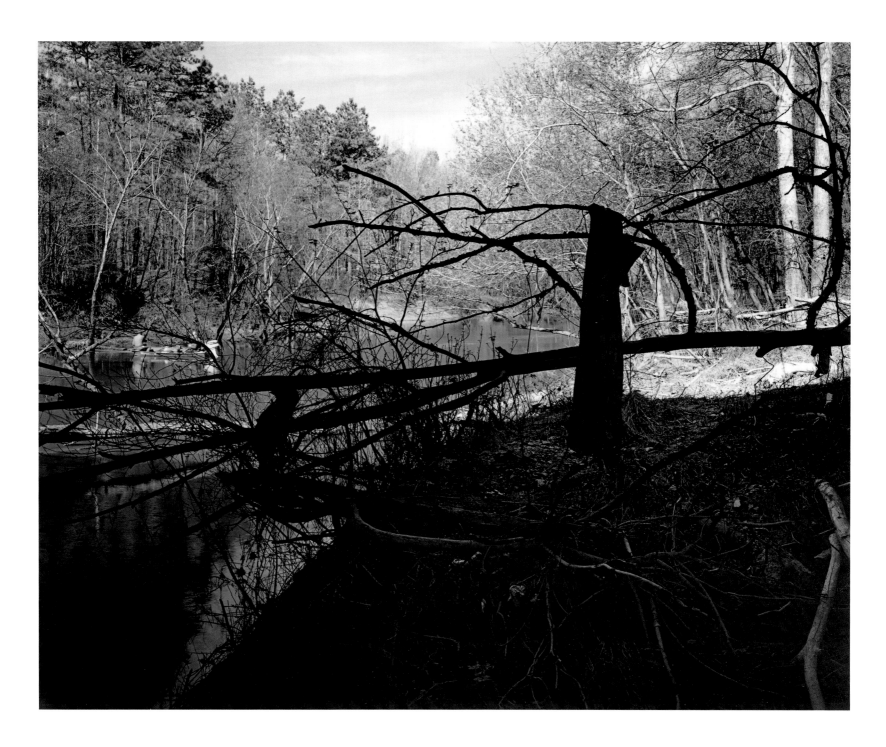

30 April 1864
1,597 American Casualties

Site of the River Crossing and Battle
JENKINS' FERRY, ARKANSAS

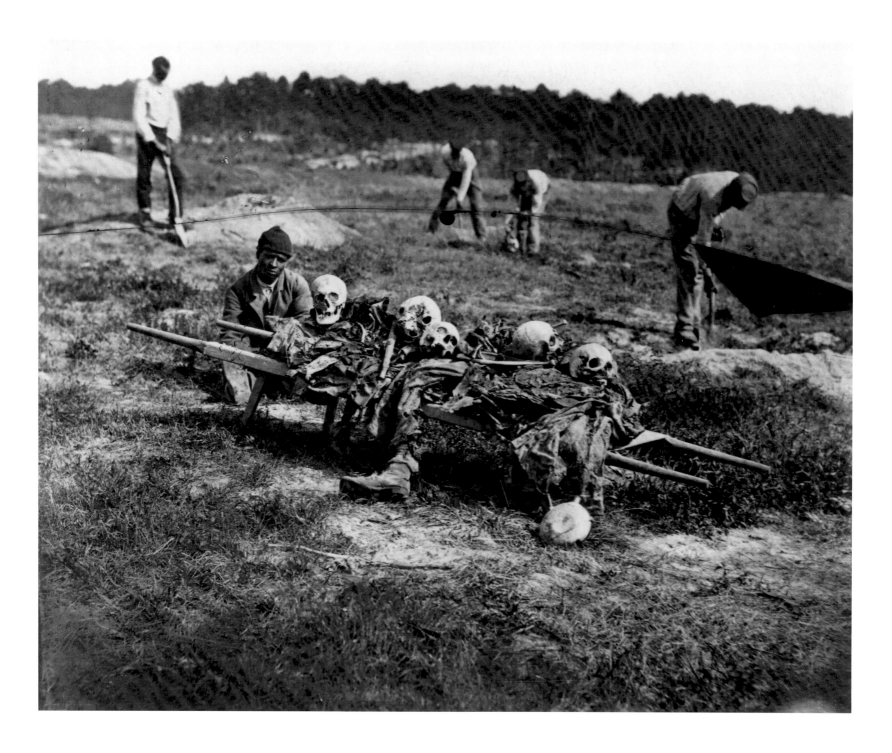

1–3 June 1864

COLD HARBOR, VIRGINIA

A Burial Party on the Battlefield in April 1865

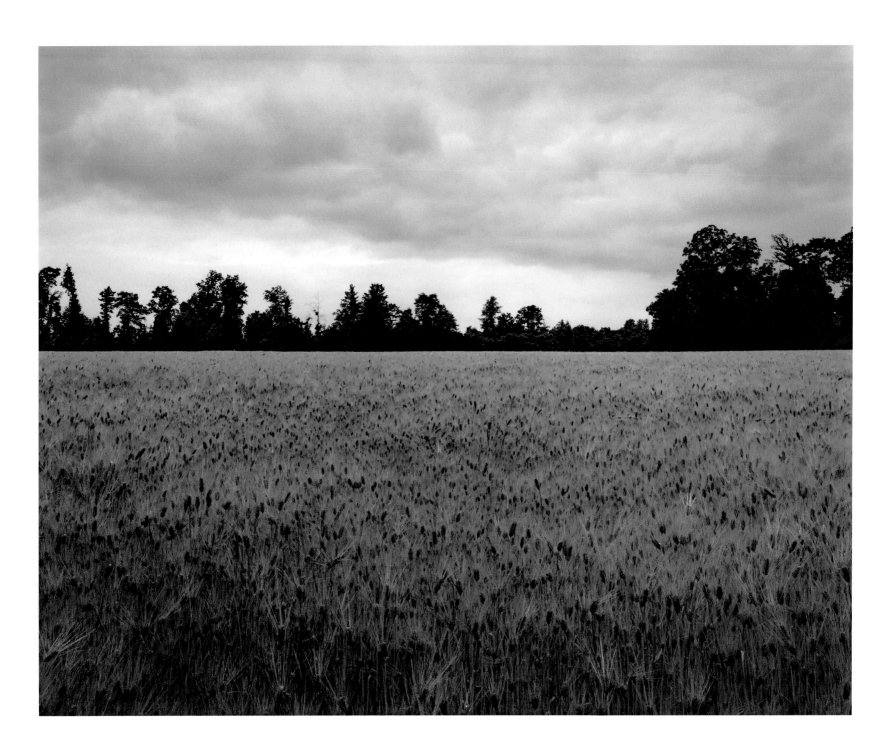

14,437 American Casualties Site of the Union Left

COLD HARBOR, VIRGINIA

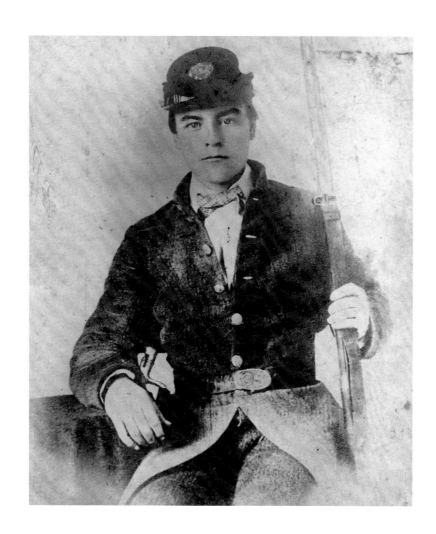

28–30 August 1862

SECOND MANASSAS, VIRGINIA

Thomas Sheppard, of Charleston, South Carolina, Age 19,
Killed at Second Manassas

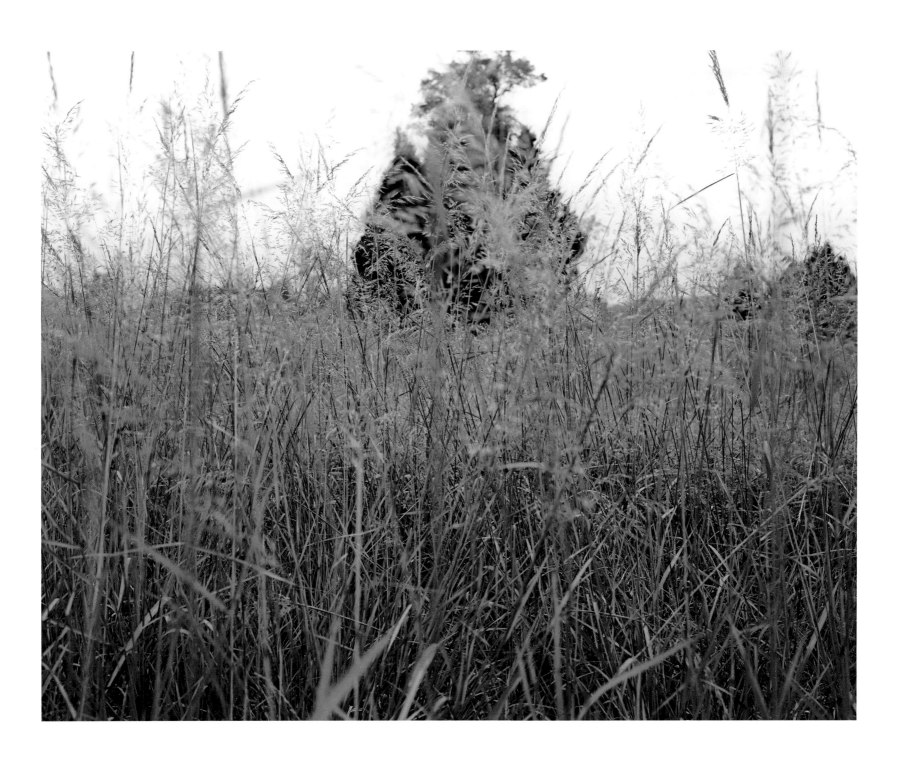

25,200 American Casualties

SECOND MANASSAS, VIRGINIA

Chinn Ridge, Site of the Beginning of the Confederate Flank
Attack on the Final Day

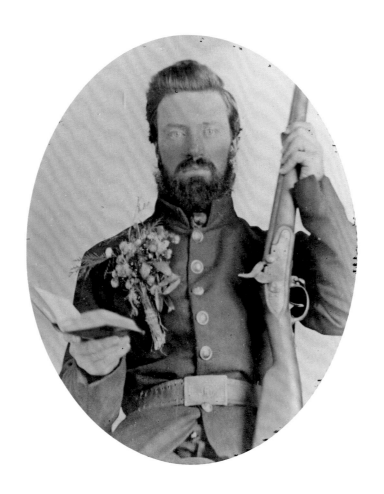

16 March 1865

AVERASBORO, NORTH CAROLINA

This Tennessee soldier fought in the
Carolinas campaign.

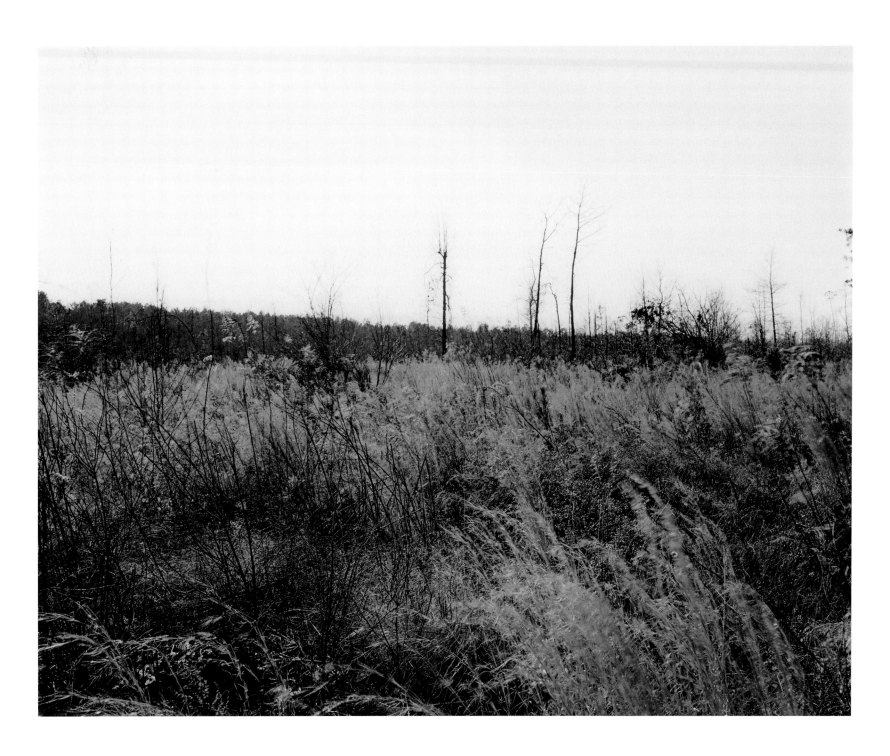

1,543 American Casualties Site of the Union Artillery on the Left Flank

AVERASBORO, NORTH CAROLINA

31 December 1862–2 January 1863 Site of the Confederate Right Center

MURFREESBORO, TENNESSEE

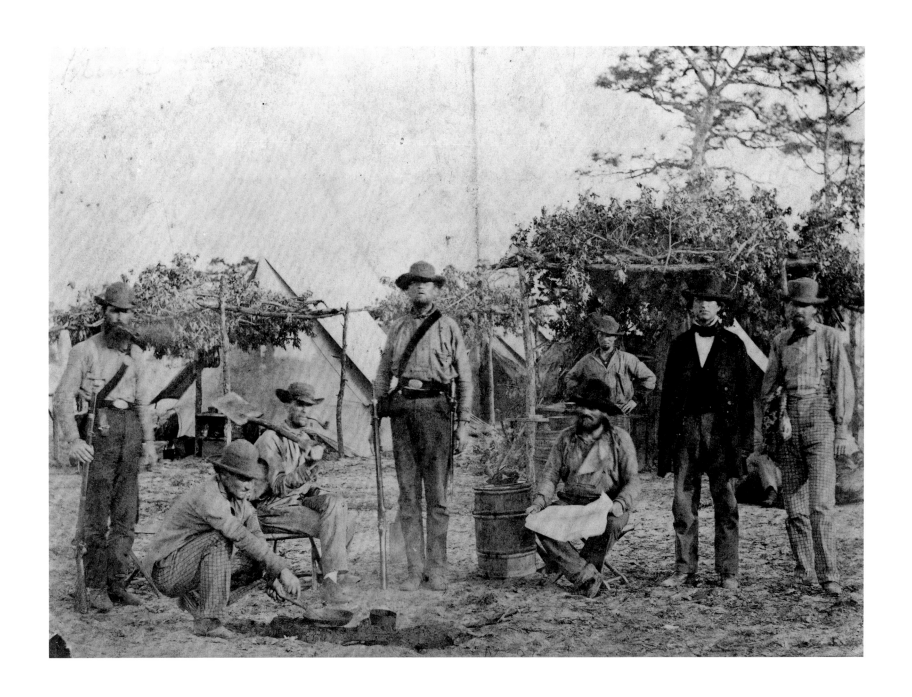

23,515 American Casualties

MURFREESBORO, TENNESSEE

The 9th Mississippi Infantry fought here.

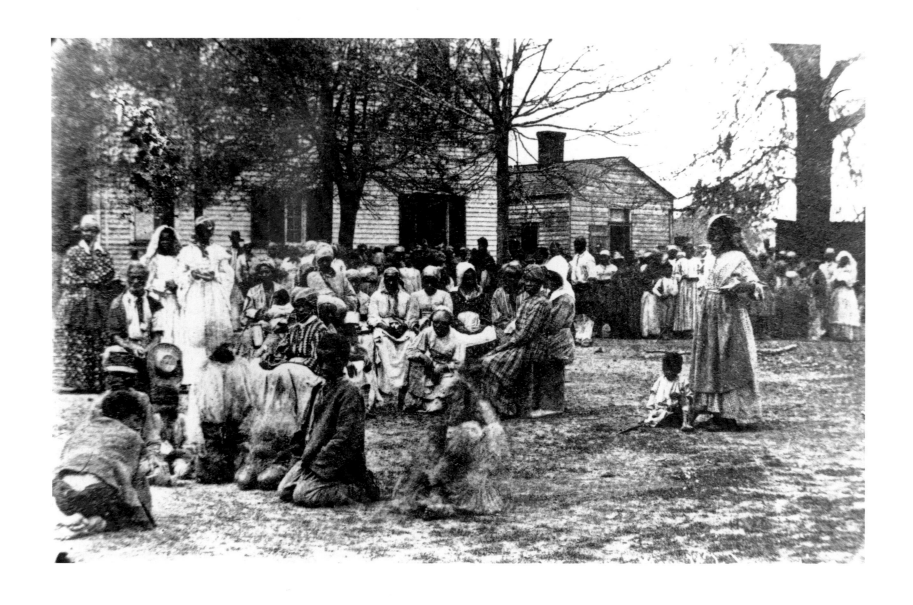

14 May 1863

JACKSON, MISSISSIPPI

Slaves were photographed at a wedding on the plantation of
Jefferson Davis before the war.

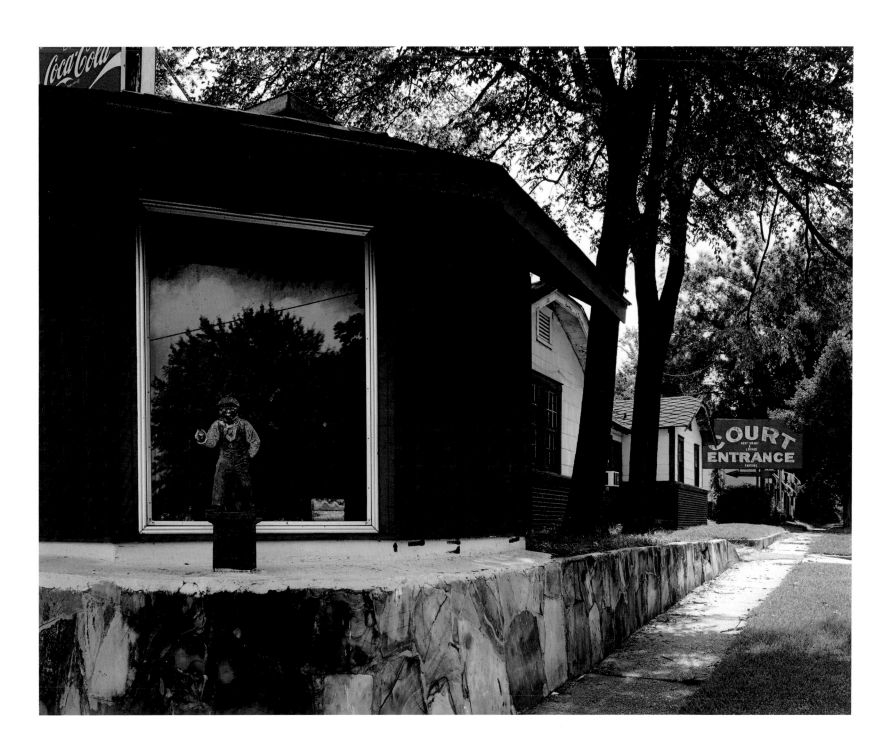

550 American Casualties

Location of the Confederate Southwestern Defenses

JACKSON, MISSISSIPPI

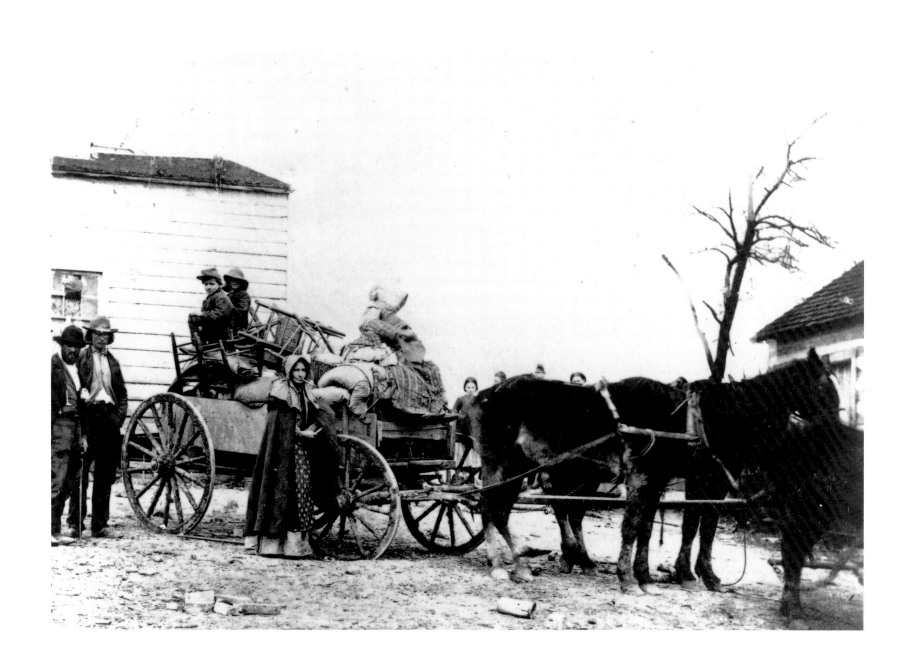

Southern Refugees

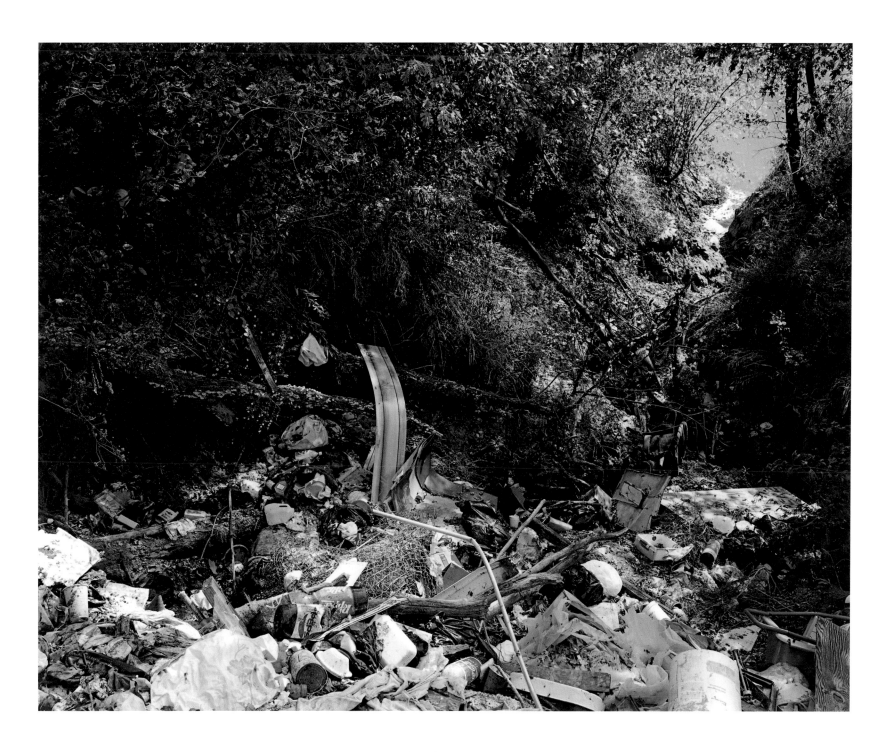

9 December 1861
102 American Casualties

The center of the fighting was here. Much of the battlefield is a working oil field.

CHUSTO-TALASAH, CHEROKEE NATION, INDIAN TERRITORY

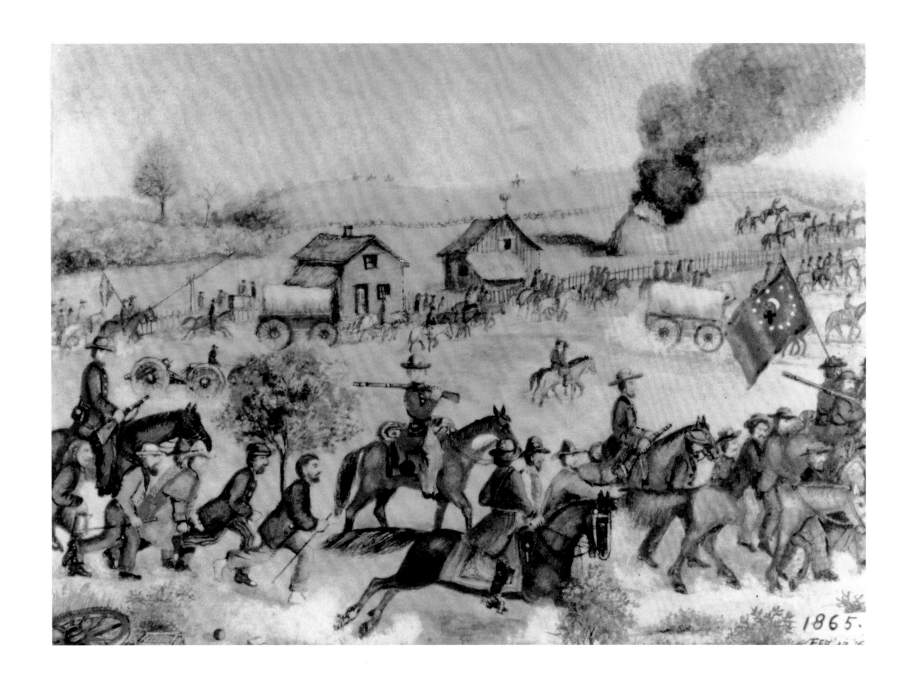

1865.

25 October 1864

MINE CREEK AND LITTLE OSAGE, KANSAS

Samuel Reader, a Union soldier captured by the Confederates, later painted this picture of the march through Kansas.

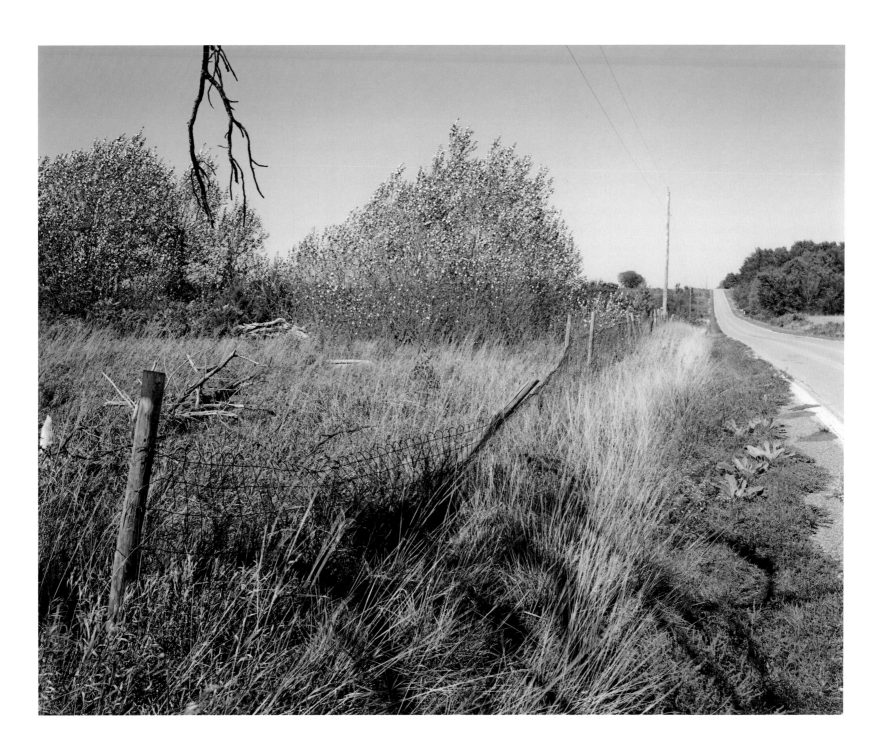

1,500 American Casualties

North of the Little Osage River, the Left of the Second Union Position

MINE CREEK AND LITTLE OSAGE, KANSAS

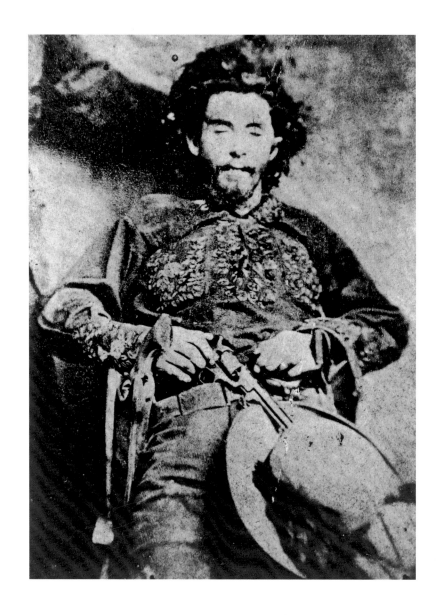

21 August 1863

LAWRENCE, KANSAS

William Anderson, one of Quantrill's Confederate guerrillas responsible for the massacre, was photographed after being killed one year later.

204 American Casualties

LAWRENCE, KANSAS

The guerrillas murdered their prisoners here.

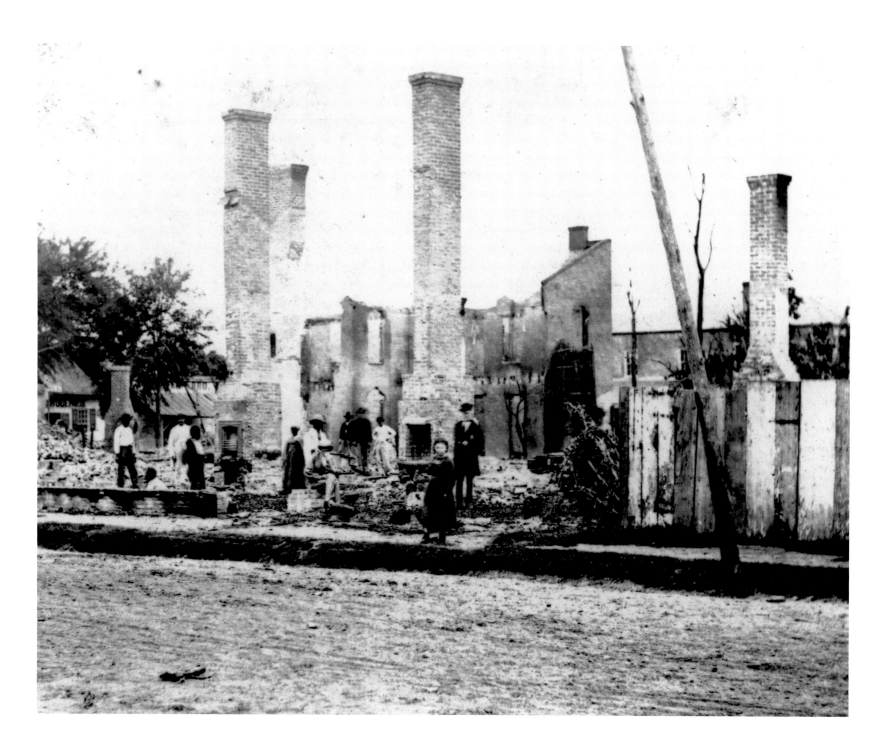

5 August 1862

BATON ROUGE, LOUISIANA

Destruction by Federal Gunboats Covering
the Union Retreat

839 American Casualties Northeastern Section of the Battlefield

BATON ROUGE, LOUISIANA

28 October 1864
500 American Casualties

Location of the Union Left, Now a Tailings Dump
NEWTONIA, MISSOURI

10–16 July 1863

2,339 American Casualties

Location of the Confederate Trenches that Received the Attack on 12 July

JACKSON, MISSISSIPPI

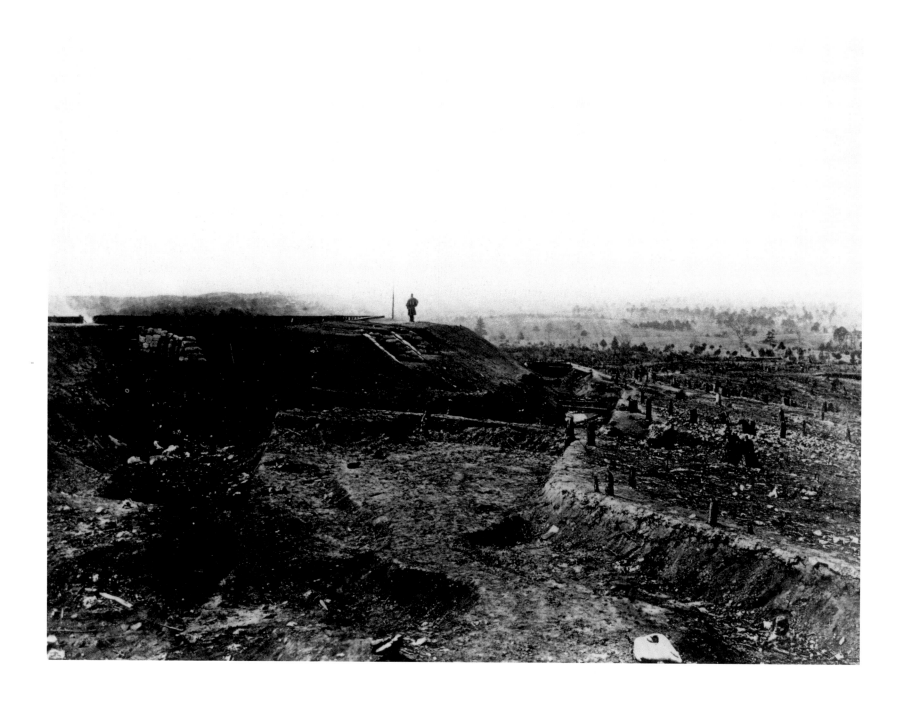

17 November–4 December 1863

KNOXVILLE, TENNESSEE

The Earthworks of Fort Sanders, Which the Confederates
Attacked on 29 November

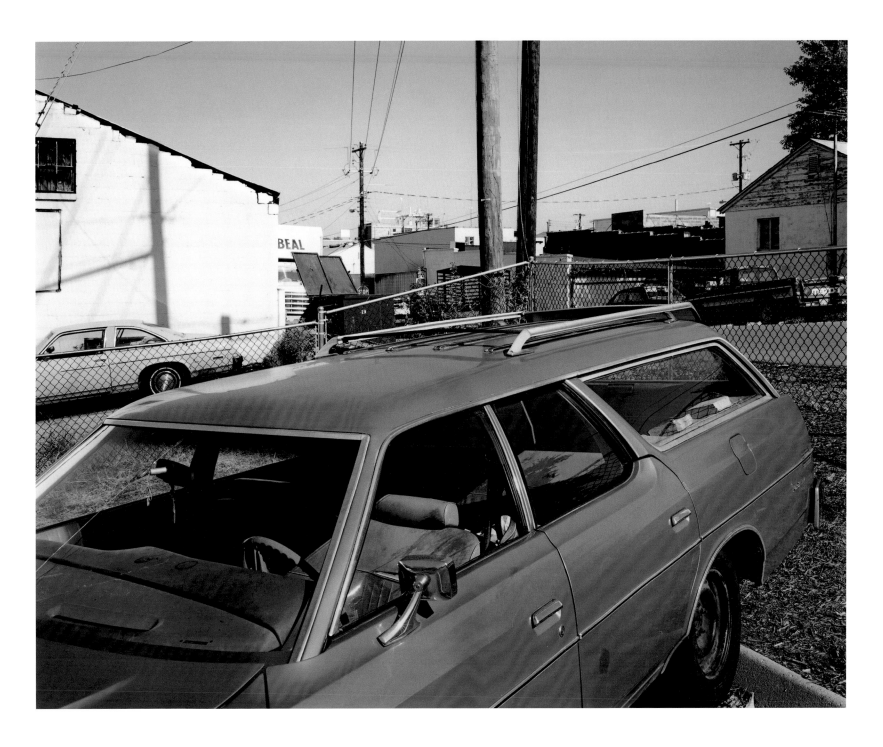

1,977 American Casualties

KNOXVILLE, TENNESSEE

Position of the Union Right, First Line,
in front of Fort Sanders

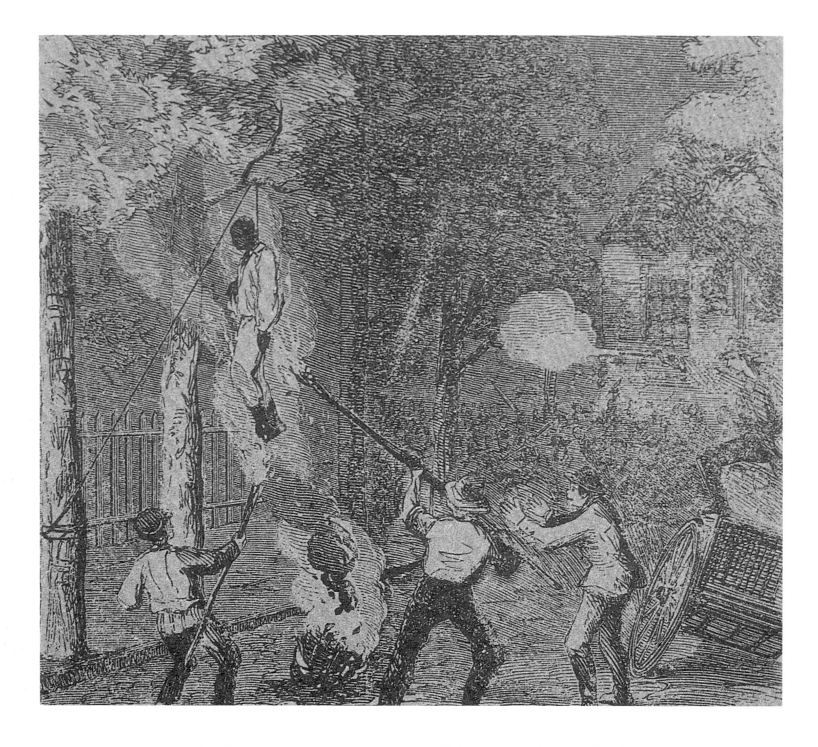

13–15 July 1863

NEW YORK, NEW YORK

William Jones, a black man, is lynched and burned on Clarkson Street on the first day of the draft riot.

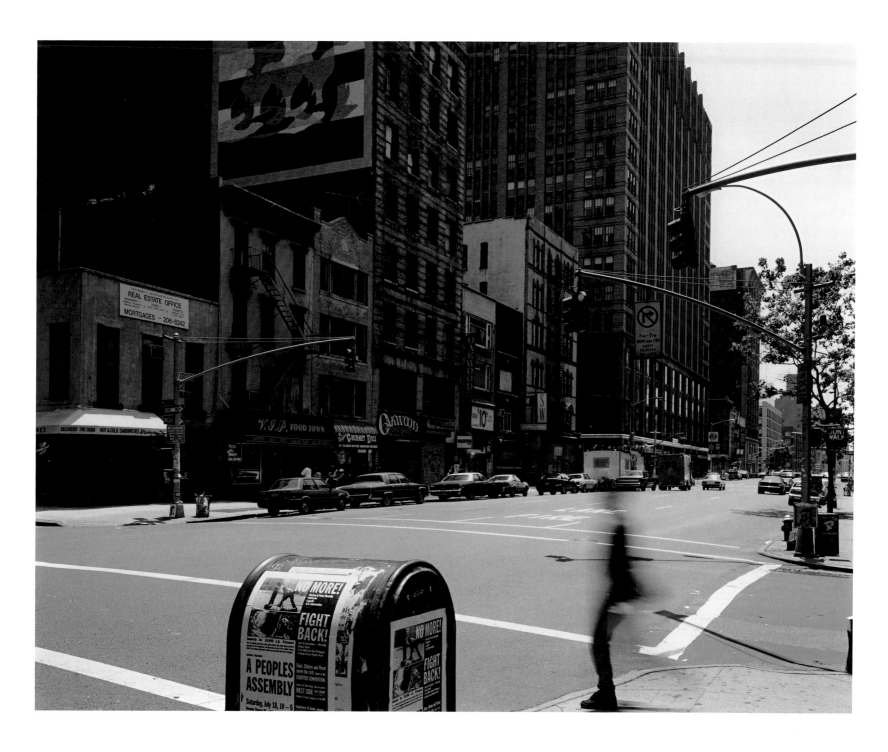

78 American Dead

NEW YORK, NEW YORK

Abraham Franklin, a twenty-three-year-old black man, was lynched here at 7th Avenue and 27th Street on the last day of the riot.

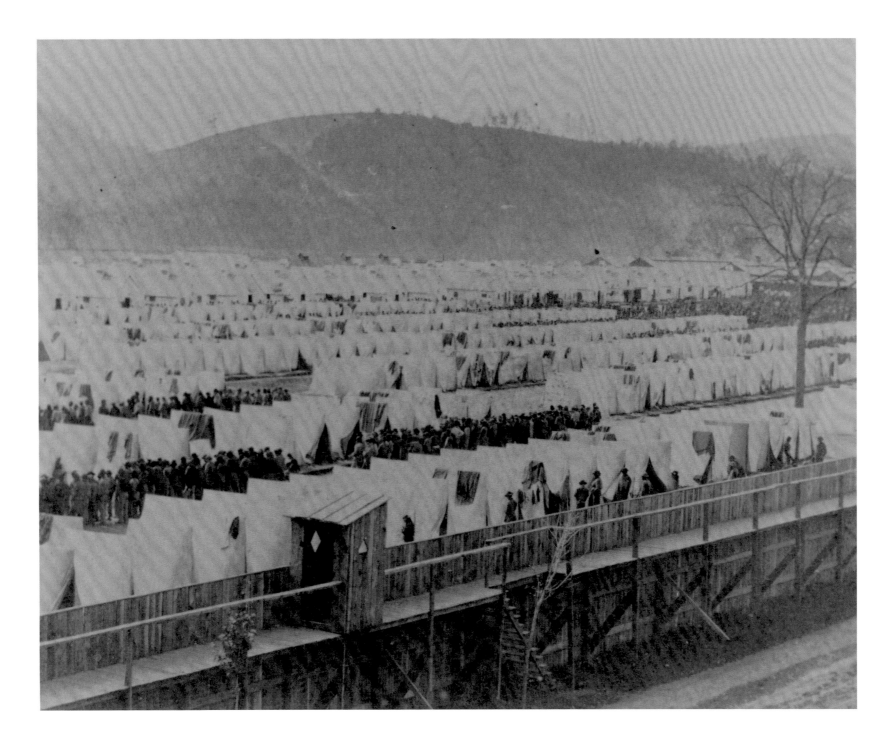

July 1864–June 1865

ELMIRA, NEW YORK

View of the Prison

2,917 American Dead Site of the Northern Section of the Prison

ELMIRA, NEW YORK

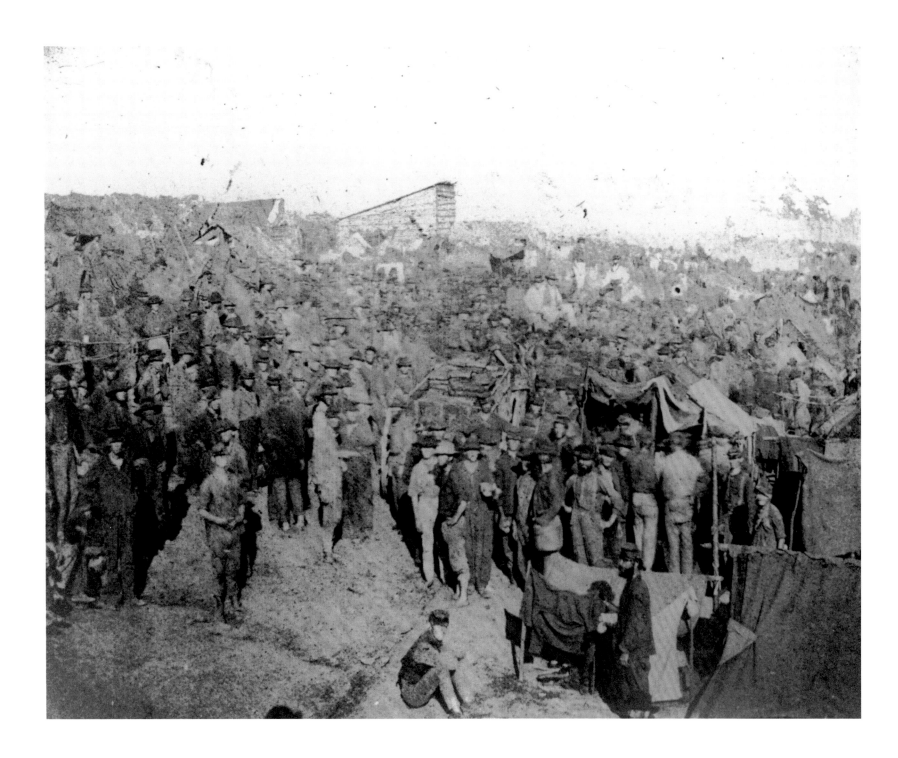

February 1864–April 1865 Prisoners

ANDERSONVILLE, GEORGIA

12,912 American Dead The Sky above the Prison

ANDERSONVILLE, GEORGIA

19–20 September 1863

34,624 American Casualties

Temporary Federal Position after the Confederate Breakthrough

CHICKAMAUGA, GEORGIA

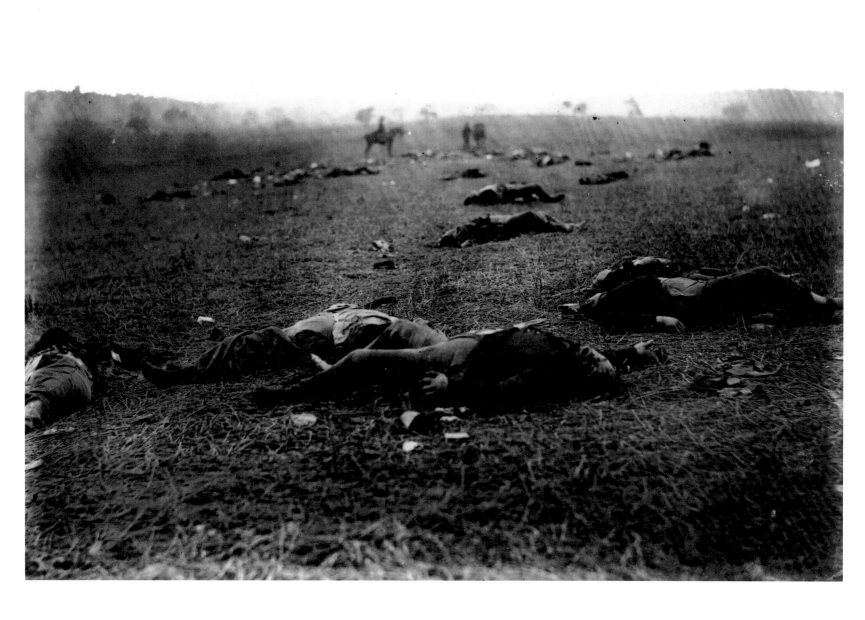

1–3 July 1863

The Union Dead

GETTYSBURG, PENNSYLVANIA

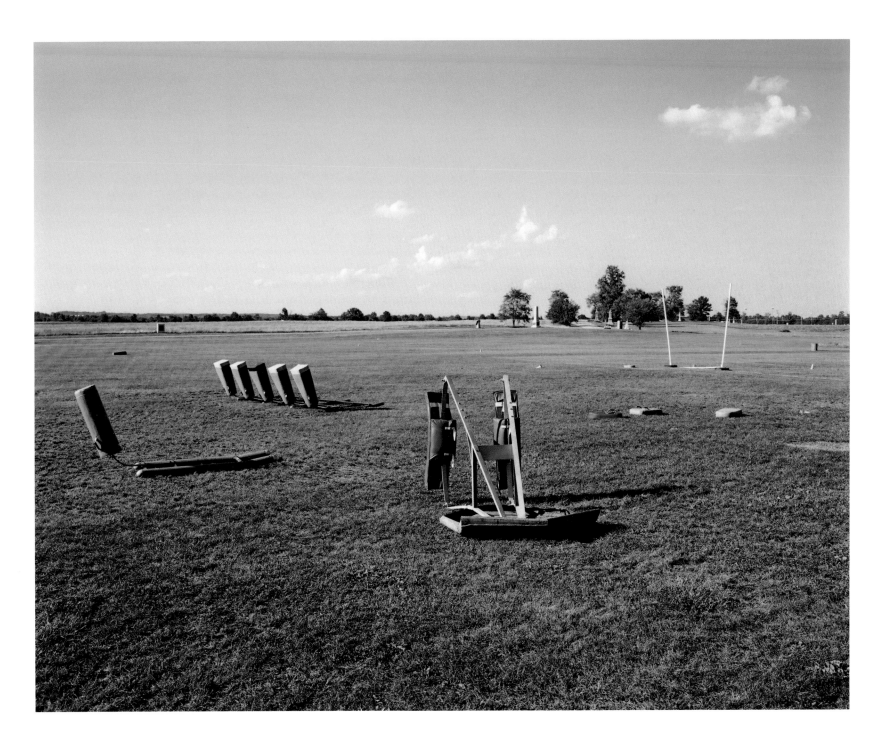

51,112 American Casualties

GETTYSBURG, PENNSYLVANIA

In the early afternoon of the first day, the Confederates forced the Federals to retreat from this position just north of the college.

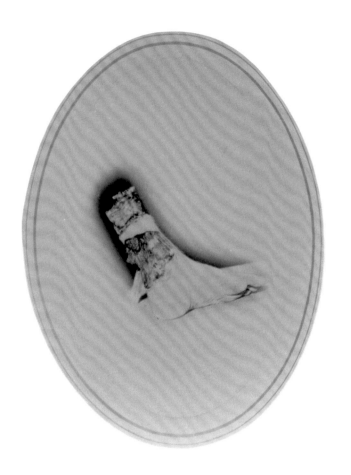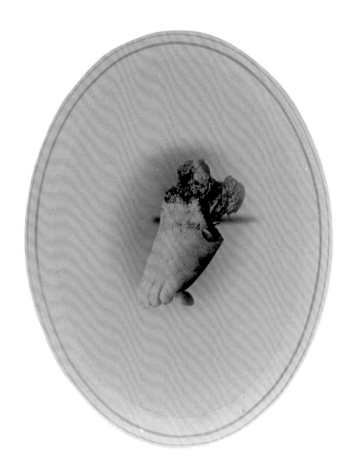

Amputated Feet

29–30 August 1862

6,050 American Casualties

Center of the First Engagement near Mt. Zion Church

RICHMOND, KENTUCKY

Just Northeast of Hazel Grove, Scene of Heavy Combat at
Chancellorsville, Virginia

William Brown, of Massachusetts, age 34, was wounded and
had his arm amputated.

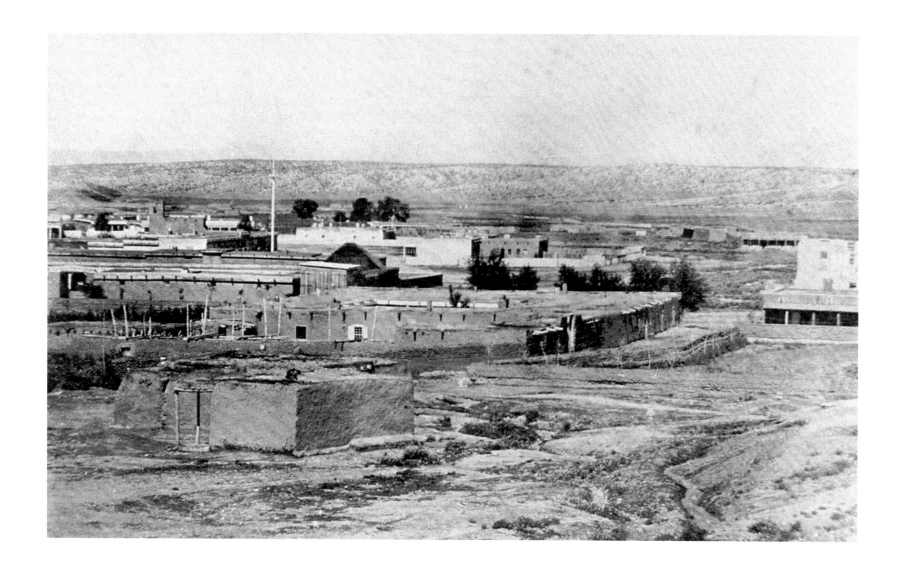

21 February 1862

VALVERDE, NEW MEXICO TERRITORY

Fort Craig, Five Miles South of the
Battlefield, Quarters of the Union Troops

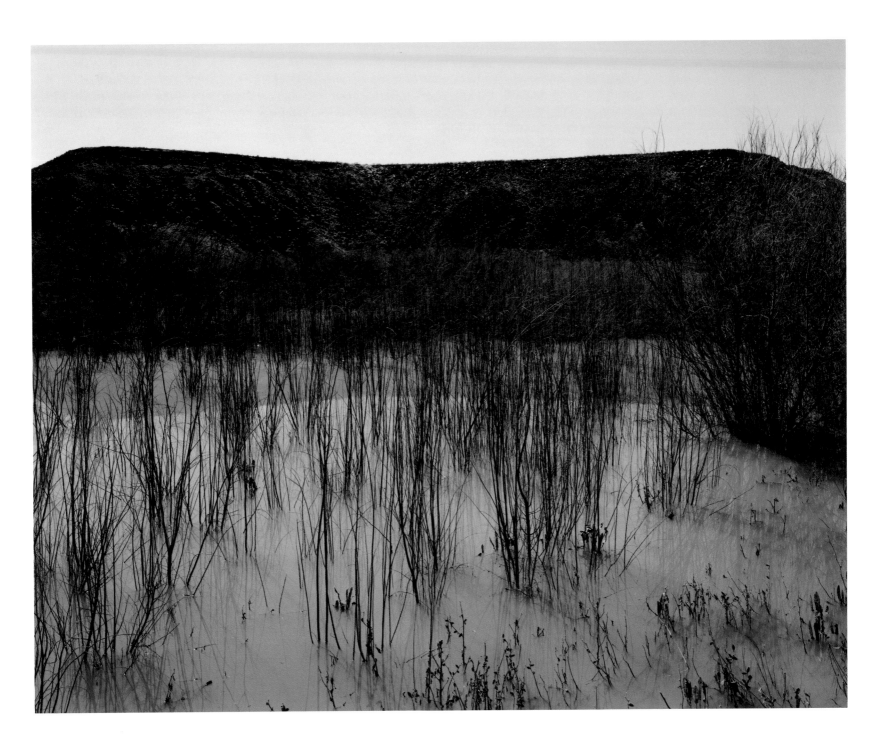

450 American Casualties

VALVERDE, NEW MEXICO TERRITORY

View to the South from the Union Left. This battlefield is twenty-five miles west of the Trinity Site, where the first atomic bomb was tested.

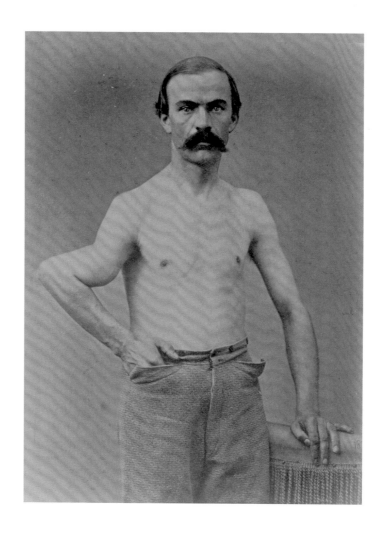

26–28 March 1862 Unknown Soldier Wounded in the New Mexico Campaign

LA GLORIETA PASS, NEW MEXICO TERRITORY

432 American Casualties The Center of the Battle on the Last Day

LA GLORIETA PASS, NEW MEXICO TERRITORY

23–25 November 1863

CHATTANOOGA, TENNESSEE

The Battleground on Lookout Mountain

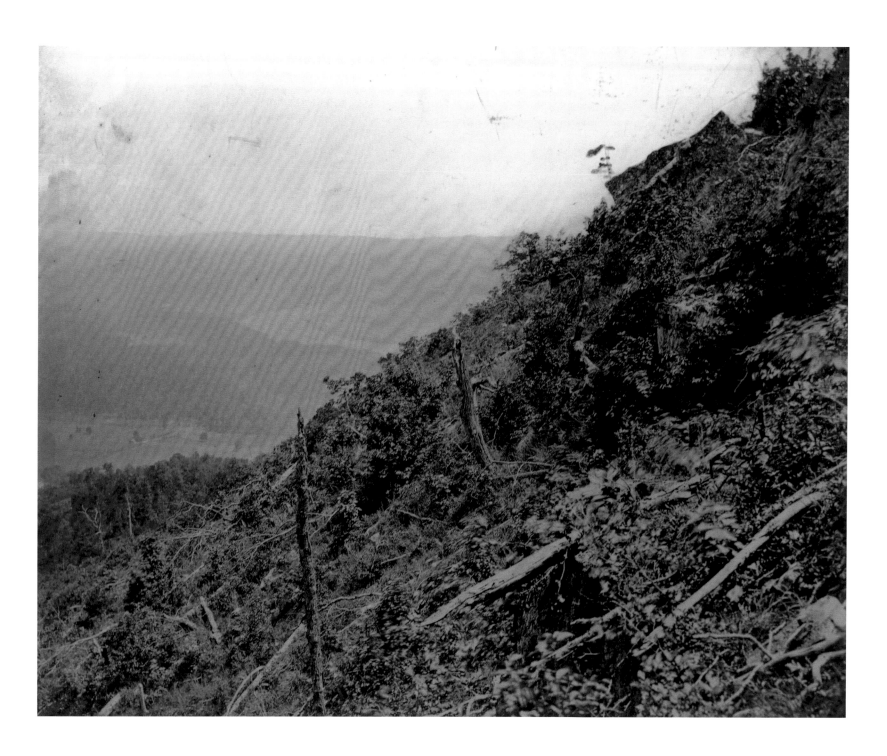

12,491 American Casualties

The Left of the First Confederate
Position on Lookout Mountain

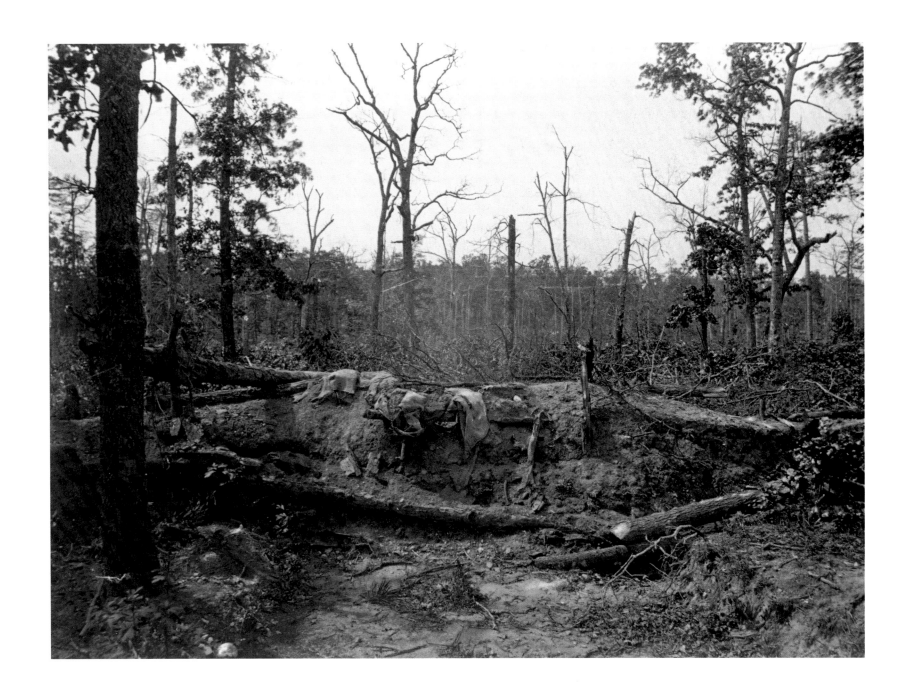

120

Confederate Entrenchments

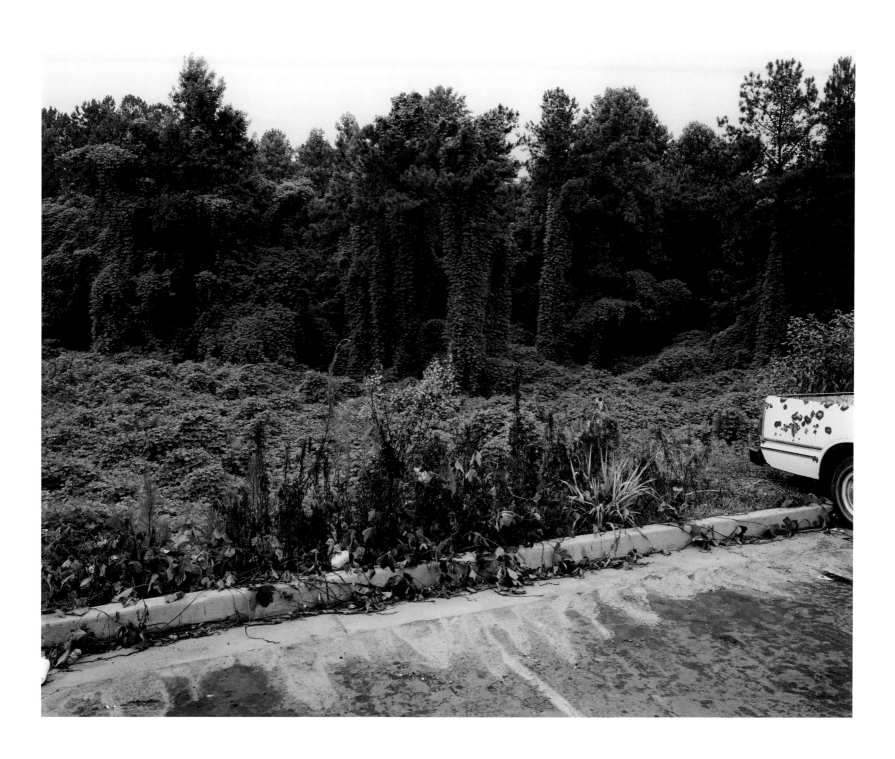

4,690 American Casualties Site of the Confederate Right Center

NEW HOPE CHURCH, GEORGIA

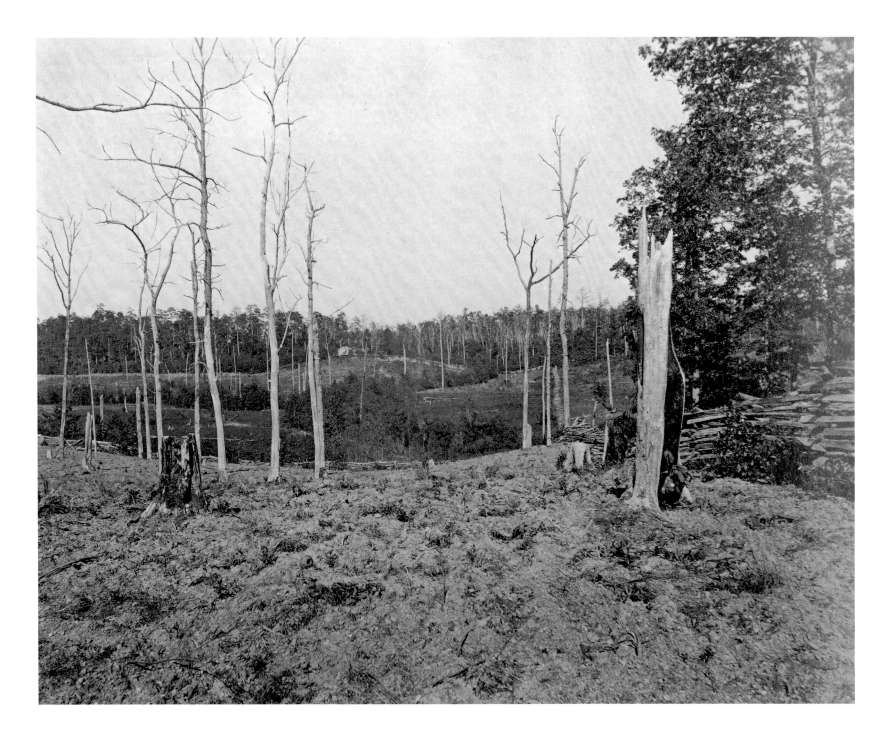

14–15 May 1864

The Battlefield

RESACA, GEORGIA

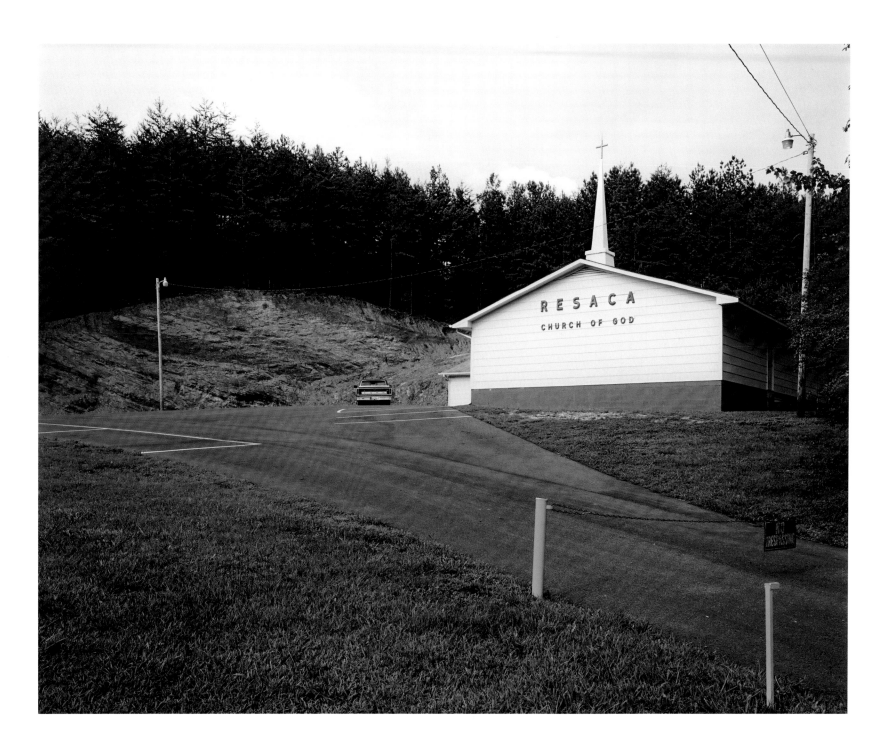

5,547 American Casualties

RESACA, GEORGIA

Position of the Confederate Center on
the North

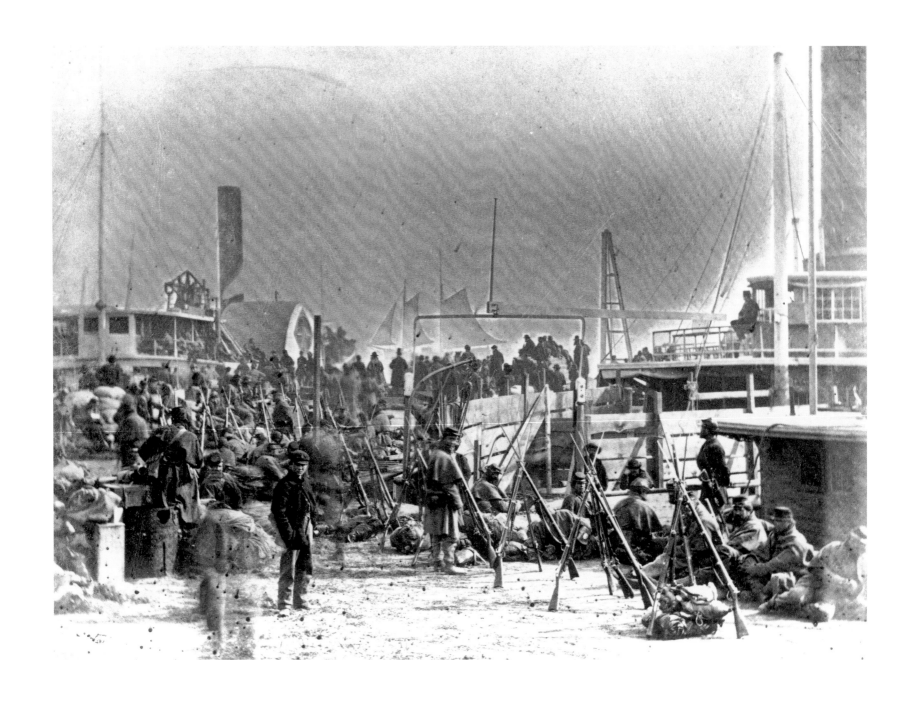

Union soldiers depart from Aquia Creek
Landing, Virginia, in February 1863.

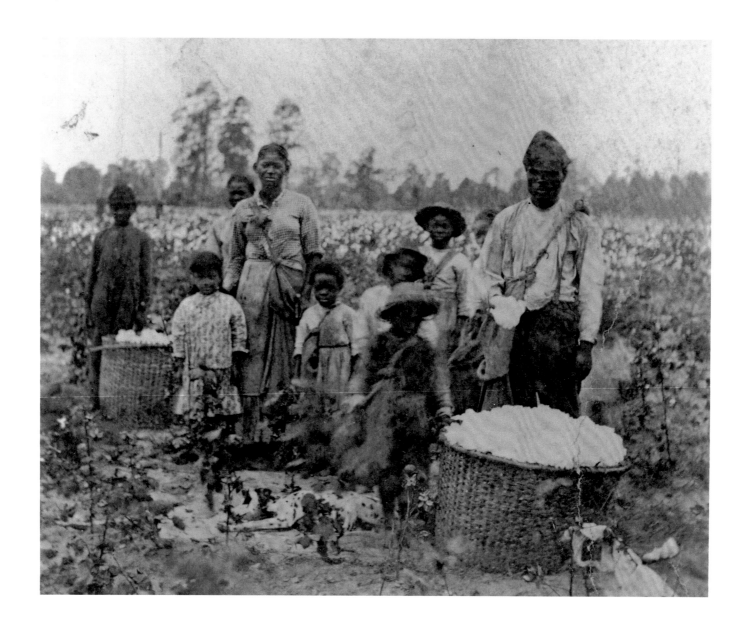

A Family of Slaves in a Georgia Cotton Field

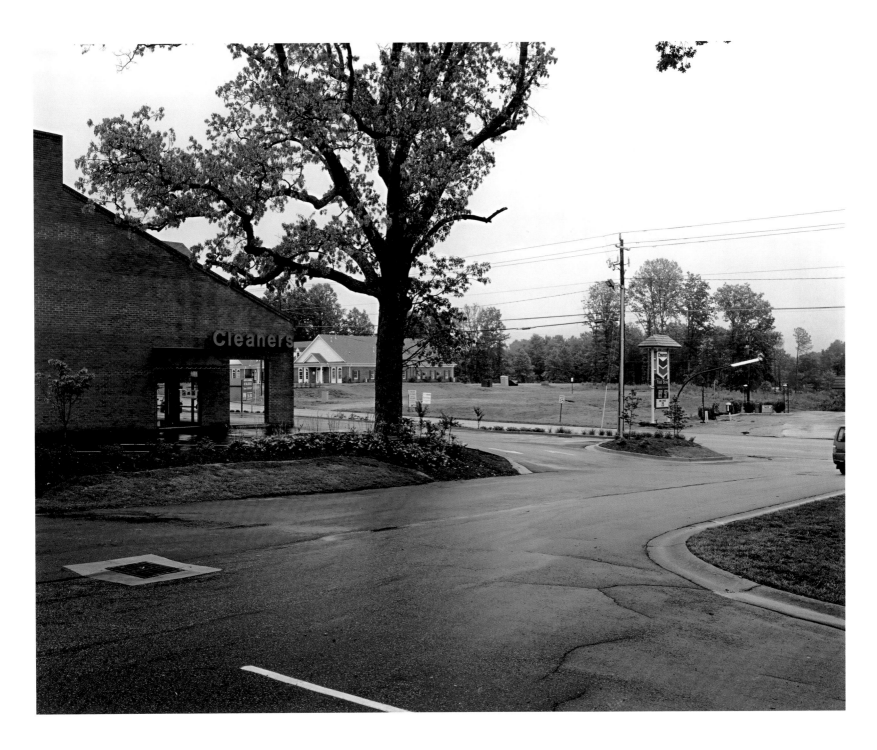

2–5 July 1864

470 American Casualties

The Battlefield near Ruff's Mill

SMYRNA, GEORGIA

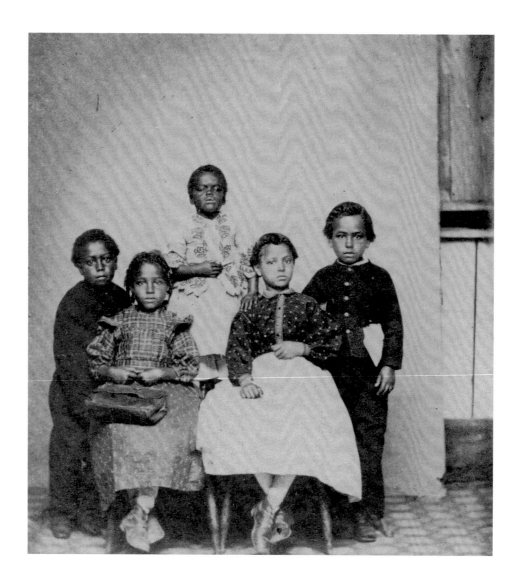

14 March 1862

NEW BERN, NORTH CAROLINA

Later in 1862 ex-slave children attend a Union-sponsored school that was briefly open here.

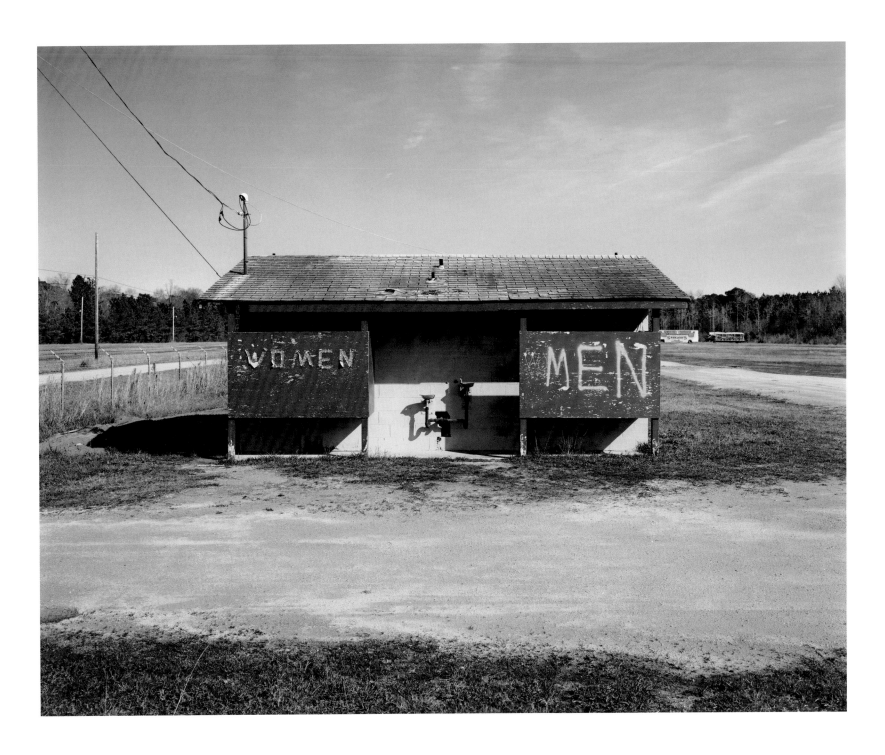

1,140 American Casualties

The Center of the Confederate Defensive Position

NEW BERN, NORTH CAROLINA

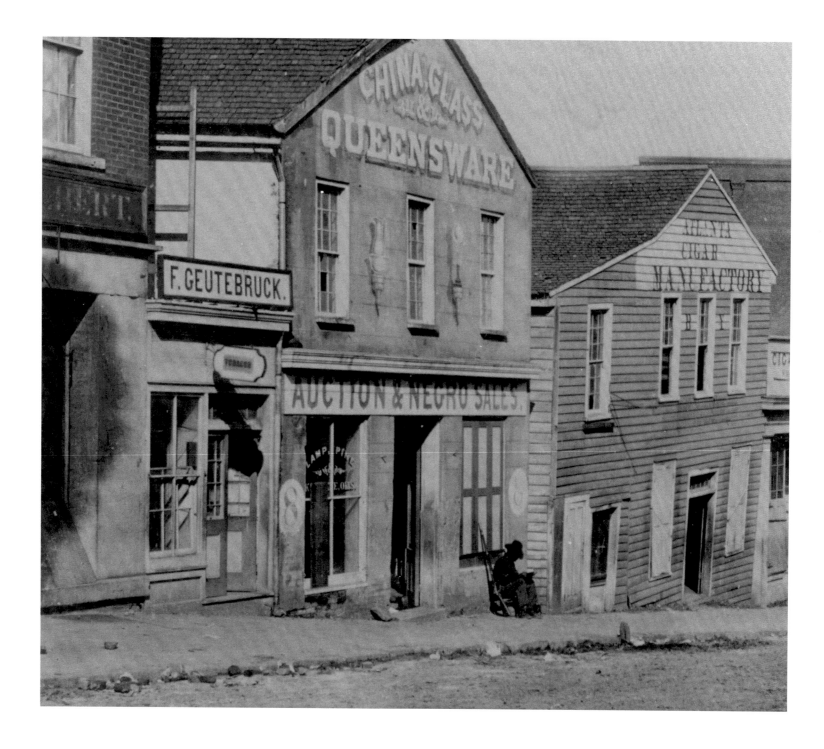

31 August–1 September 1864 Slave Market in Nearby Atlanta

JONESBORO, GEORGIA

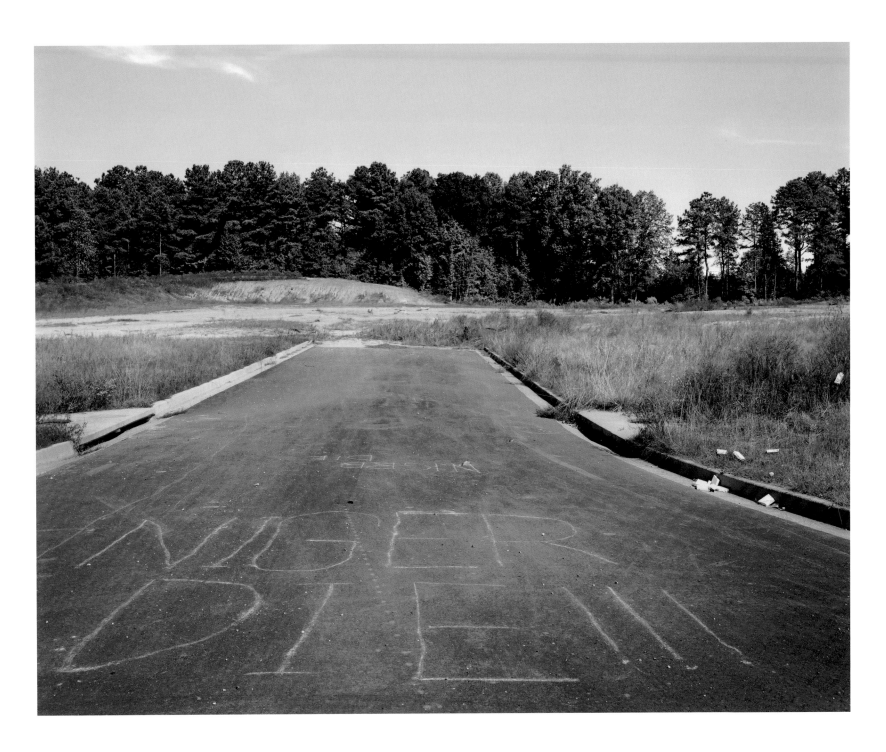

4,691 American Casualties Center of the Battle on the First Day

JONESBORO, GEORGIA

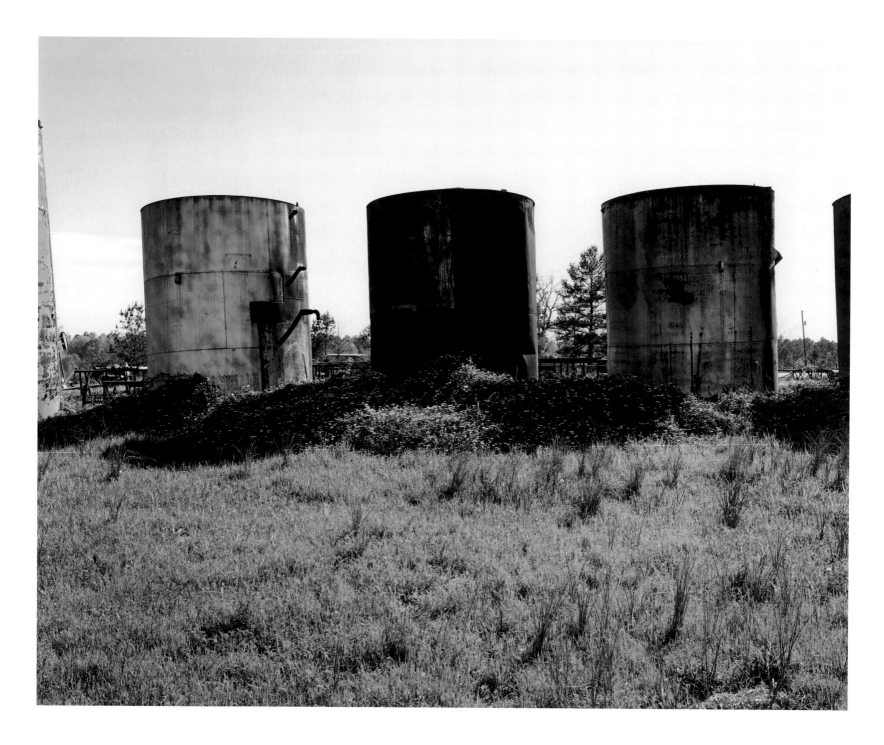

8–9 April 1864 The Eastern Section of the Battlefield at Wilson's Farm

SABINE CROSSROADS AND PLEASANT HILL, LOUISIANA

7,700 American Casualties At the Reenactors' Confederate Ball, 1983

SABINE CROSSROADS AND PLEASANT HILL, LOUISIANA

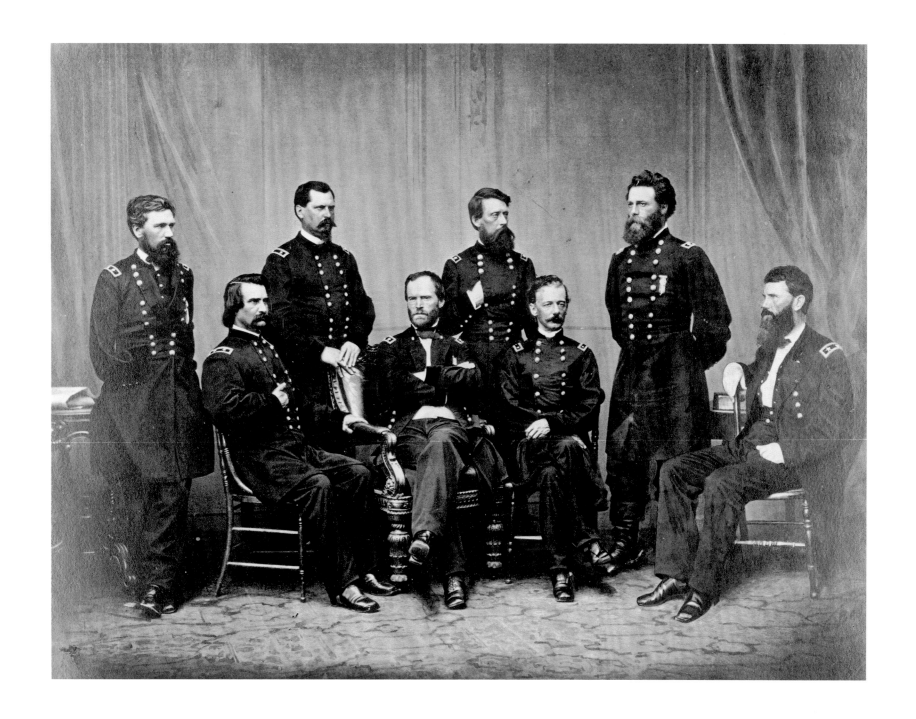

20 July 1864 Sherman and His Generals

6,575 American Casualties Site of the Confederate Right

PEACHTREE CREEK, GEORGIA

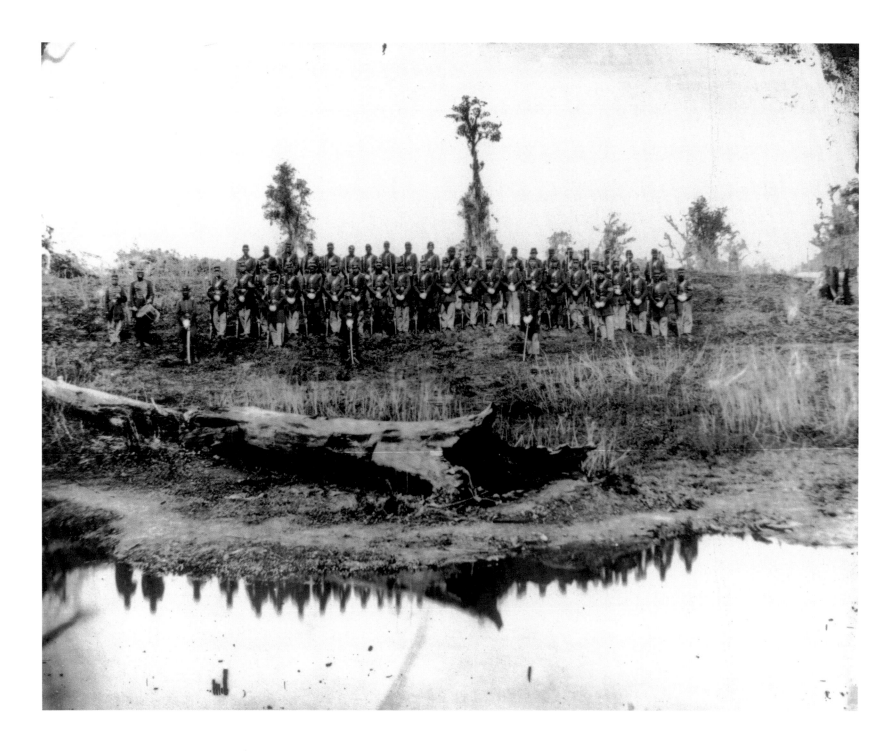

22 September 1864

The 13th Connecticut fought here.

FISHER'S HILL, VIRGINIA

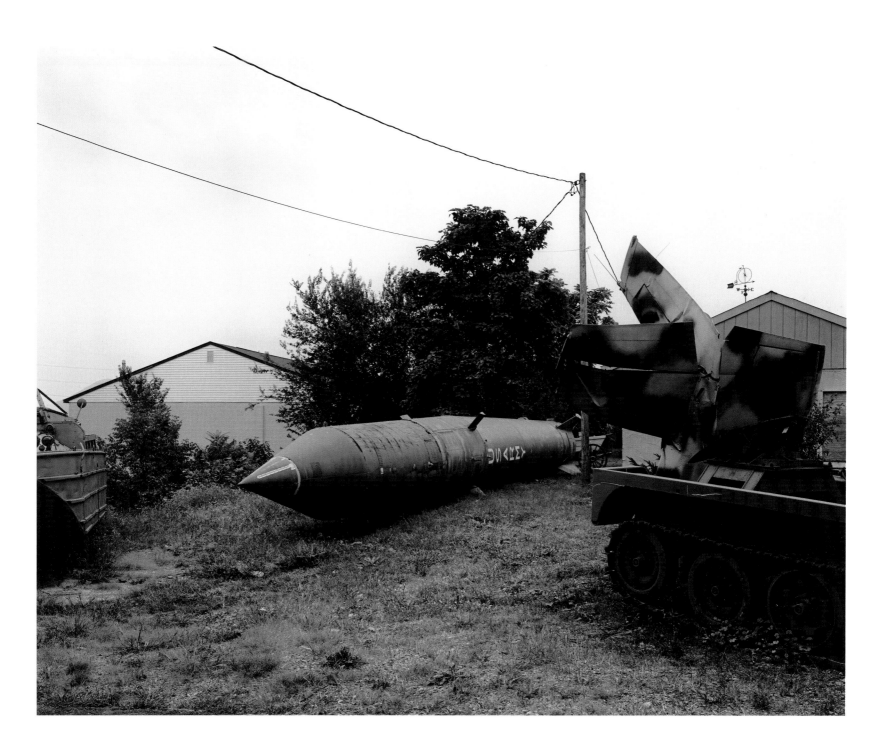

1,806 American Casualties Site of the Confederate Right

FISHER'S HILL, VIRGINIA

20 February 1864

OLUSTEE, FLORIDA

The 19th Georgia, composed of many
members of the same family, fought here.

2,806 American Casualties Position of the Confederate Right

OLUSTEE, FLORIDA

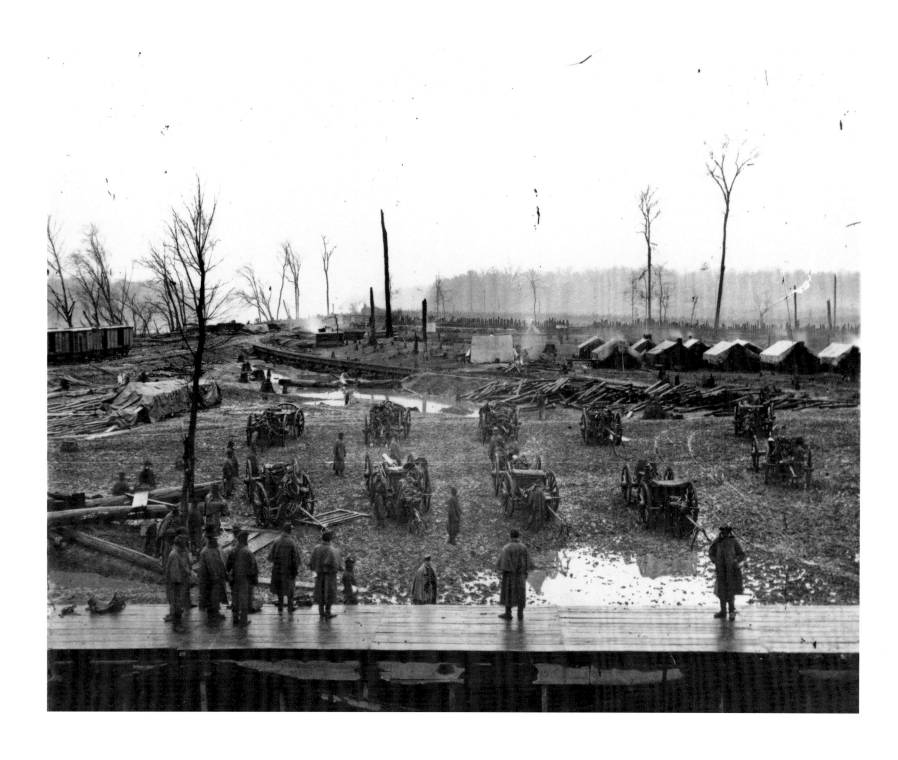

15–16 December 1864

NASHVILLE, TENNESSEE

The 1st Tennessee Colored Battery on Their
Way to the Coming Battle at Nashville

7,407 American Casualties

NASHVILLE, TENNESSEE

Site of a Rearguard Action after the
Main Battle

23–25 November 1863

CHATTANOOGA, TENNESSEE

The battle of Lookout Mountain
began here.

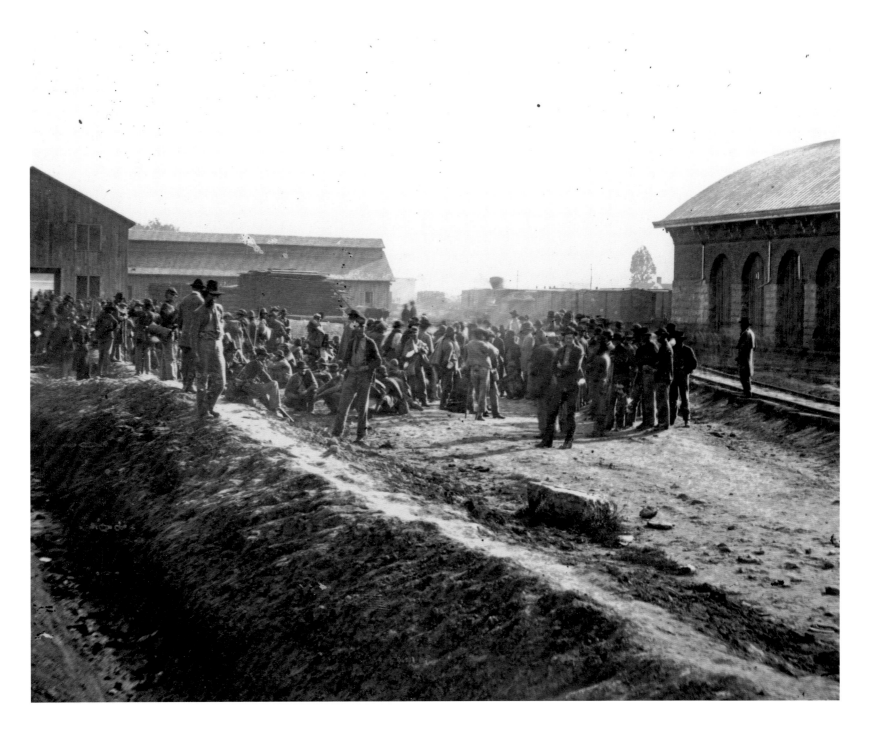

12,491 American Casualties

CHATTANOOGA, TENNESSEE

Confederate prisoners from the battle
await transportation north to prison.

30 November 1864 The first Federal line was at the stone wall.

FRANKLIN, TENNESSEE

8,526 American Casualties

Just in front of the Union Works

FRANKLIN, TENNESSEE

27 June 1864

3,750 American Casualties

The Dead Angle

KENNESAW MOUNTAIN, GEORGIA

5–7 May 1864
WILDERNESS, VIRGINIA

These Confederate breastworks in Sanders' field, photographed just after the war, were used in the heavy fighting on the Orange Turnpike.

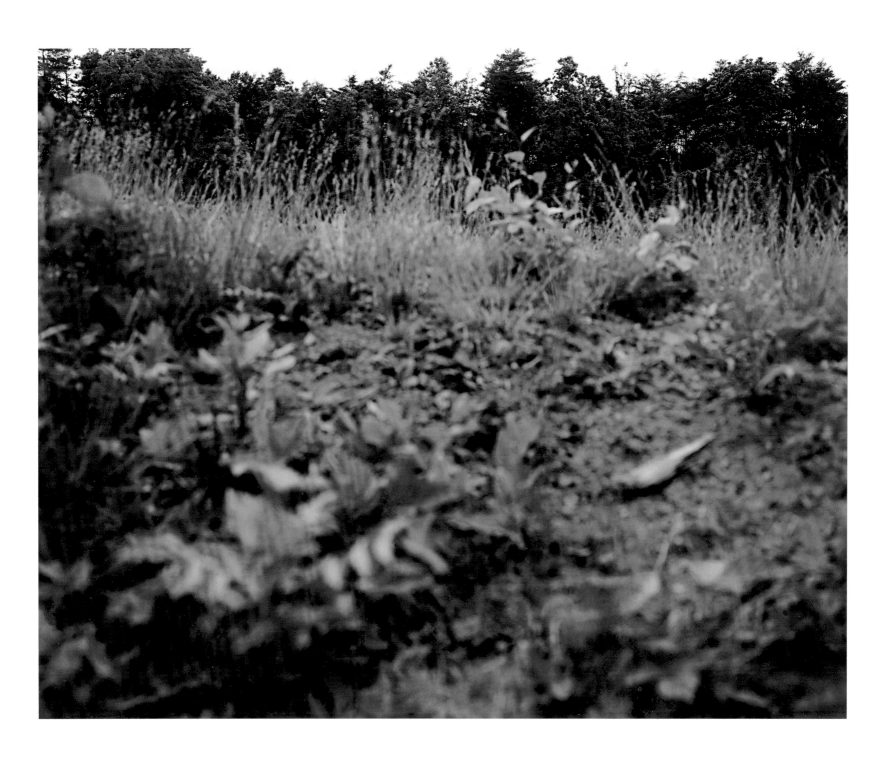

25,266 American Casualties Between the Lines at Sanders' Field

WILDERNESS, VIRGINIA

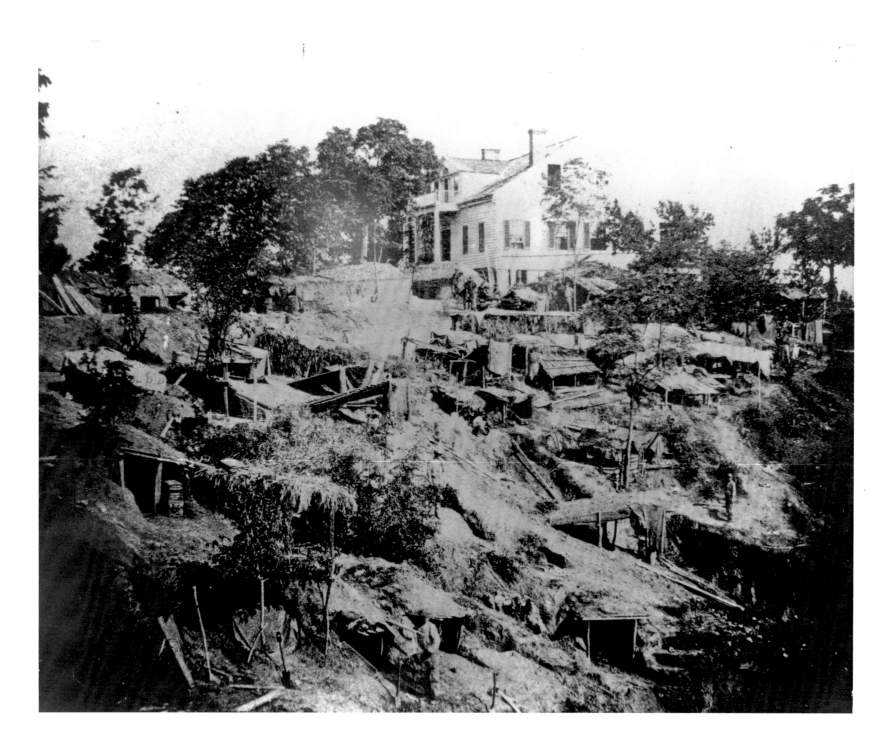

19 May–4 July 1863
VICKSBURG, MISSISSIPPI

Bombproof Quarters on the Union Line
at the Shirley House

37,293 American Casualties

VICKSBURG, MISSISSIPPI

Iraq-bound National Guardsmen at the
Shirley House, July 1990

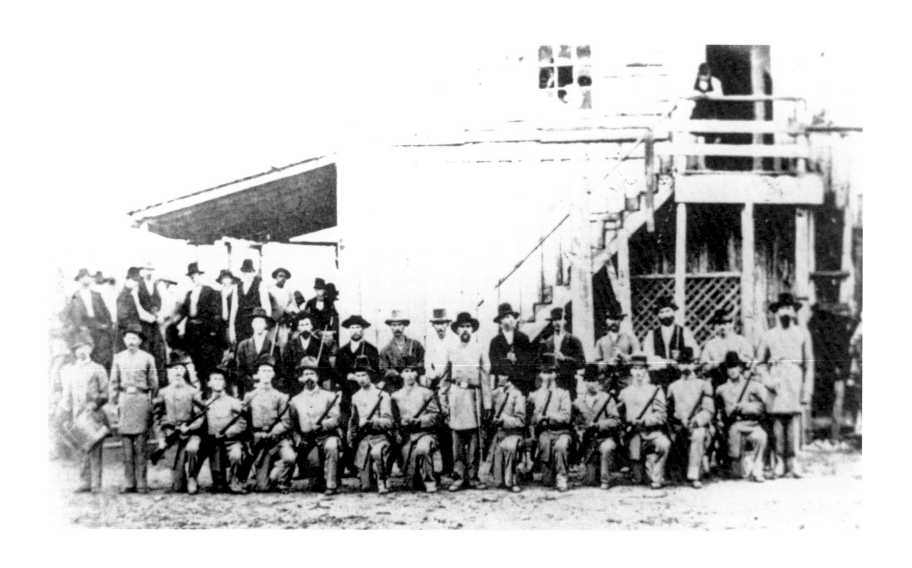

12–14 April 1863

IRISH BEND, LOUISIANA

The 4th Texas Cavalry fought here.

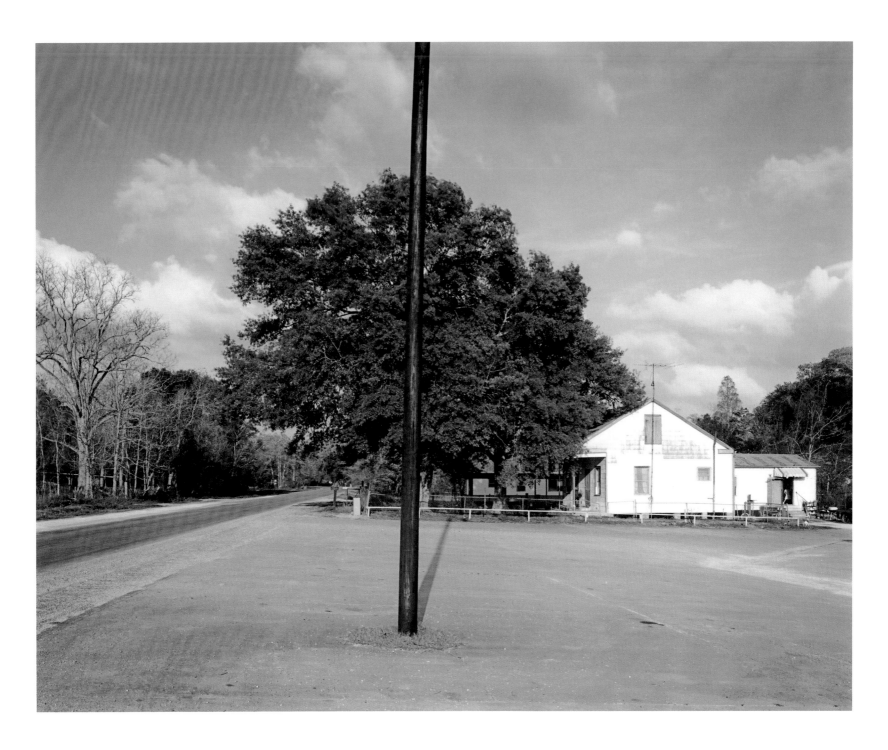

1,000 American Casualties Site of the Center of the Fighting

IRISH BEND, LOUISIANA

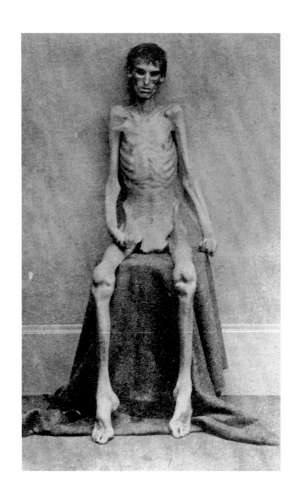

A Released Prisoner of War

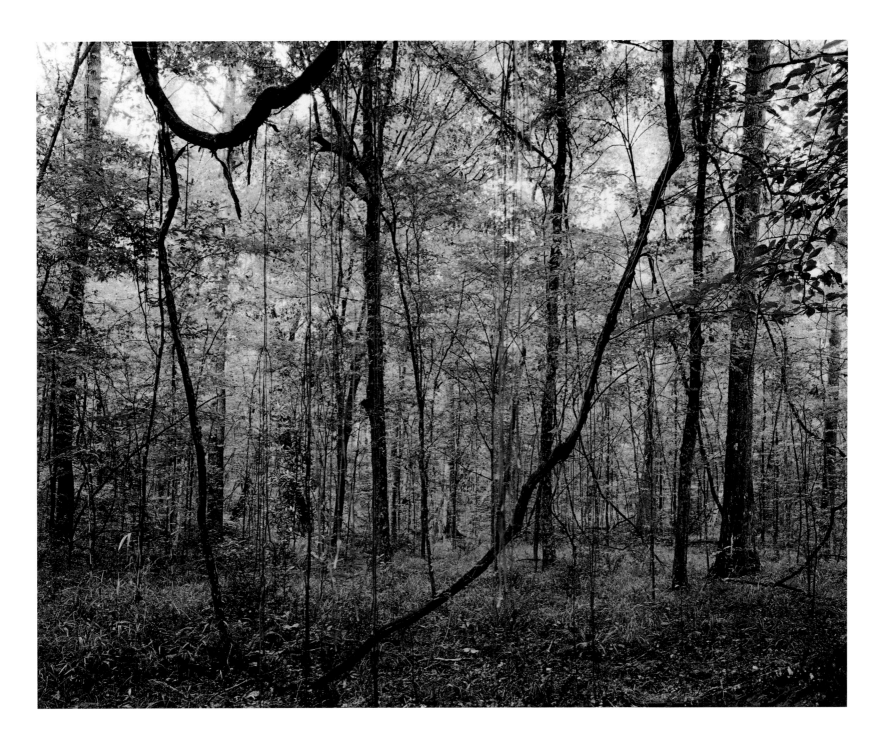

14 March–8 July 1863
10,486 American Casualties

Union Position in the First Attack on Fort Desperate
PORT HUDSON, LOUISIANA

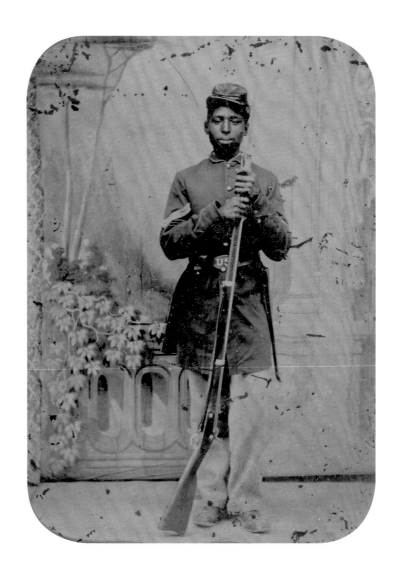

Unidentified Black Soldier

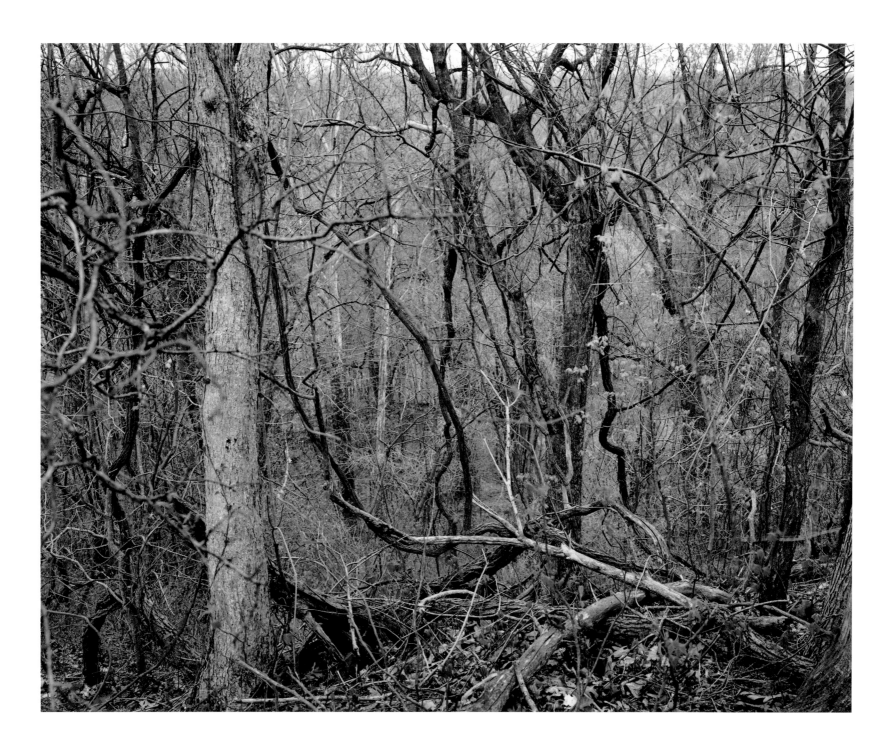

12 April 1864

657 American Casualties

Within the Inner Fort, at the Top of the Bluff

FORT PILLOW, TENNESSEE

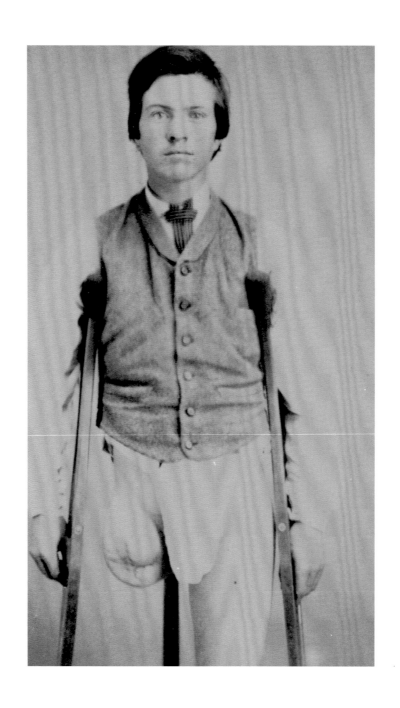

158

1–3 June 1864

COLD HARBOR, VIRGINIA

Wounded at Cold Harbor: Charles
Wormwood, of New York

Information

en Grant in
bert E. Lee
Confederate
skirmishes

ichmond's
where
the tour
cks and

roops lost in
onet charge.
g lists of
ered, but
healthy

efield

erate and
between rifle-
g of the war.

National
netery

Garthright
House

Legend
National Park Land
500' 1000'

862
864

14,437 American Casualties Site of the Confederate Center

COLD HARBOR, VIRGINIA

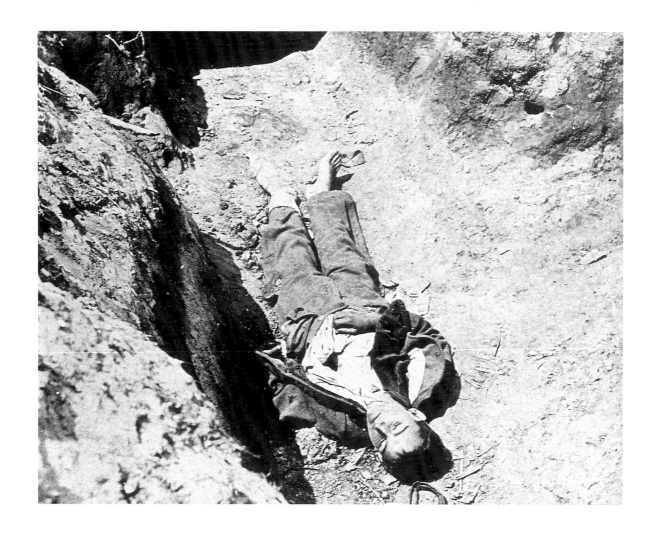

15 June 1864–2 April 1865
PETERSBURG, VIRGINIA

A Southern Soldier, about 14 Years of Age, Killed by Bayonet at
Confederate Fort Mahone on the Final Day of the Siege

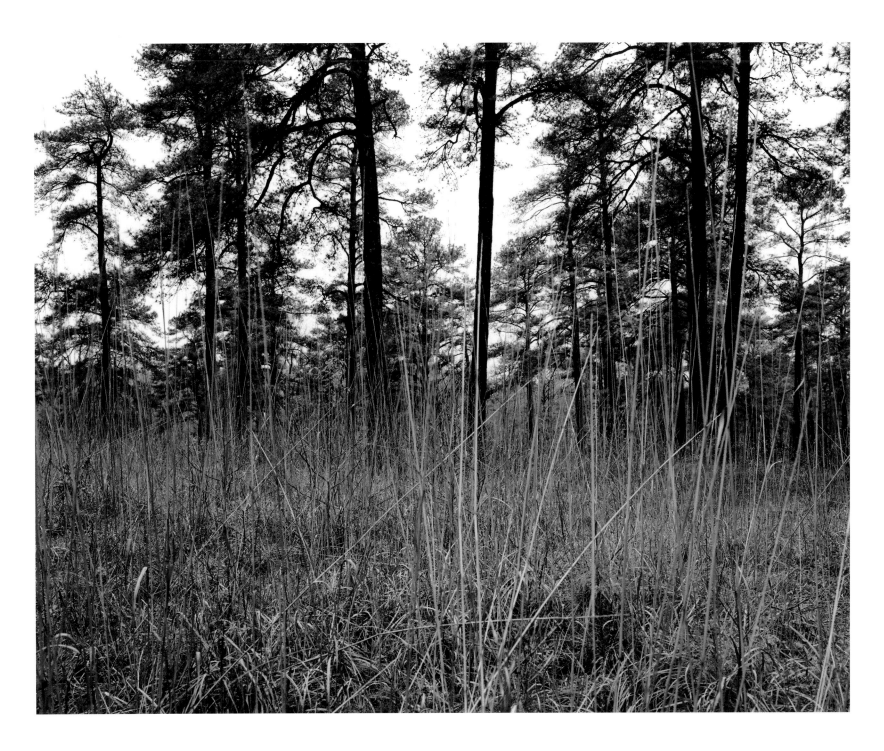

70,000 American Casualties

PETERSBURG, VIRGINIA

Site of the Confederate Line opposite
Union Fort Stedman

Let us cross over the river, and rest in the shade of the trees.

LAST WORDS OF GENERAL "STONEWALL" JACKSON

3 June 1861 Site of the Union Artillery
17 American Casualties PHILIPPI, WESTERN VIRGINIA

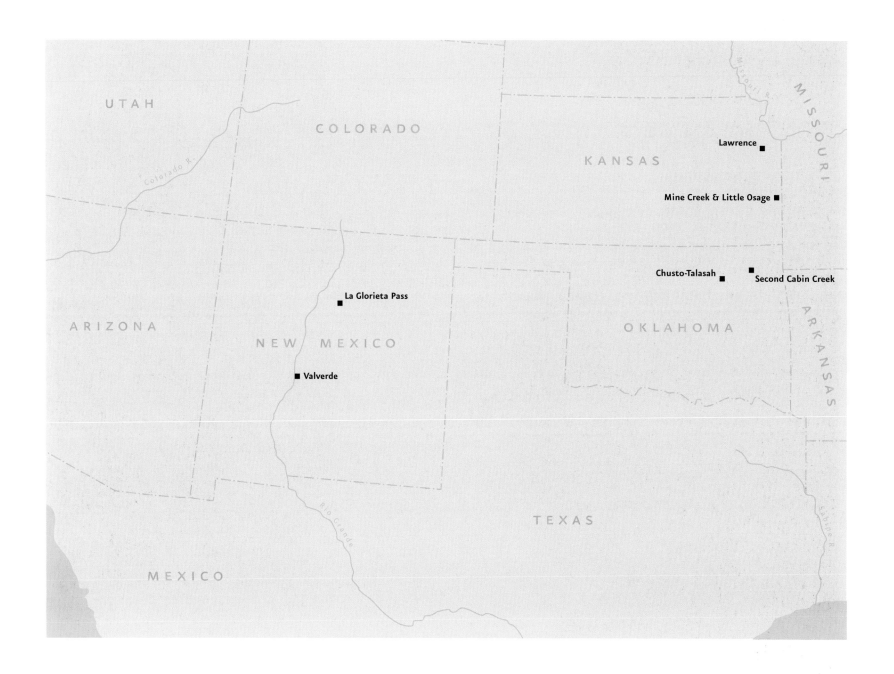

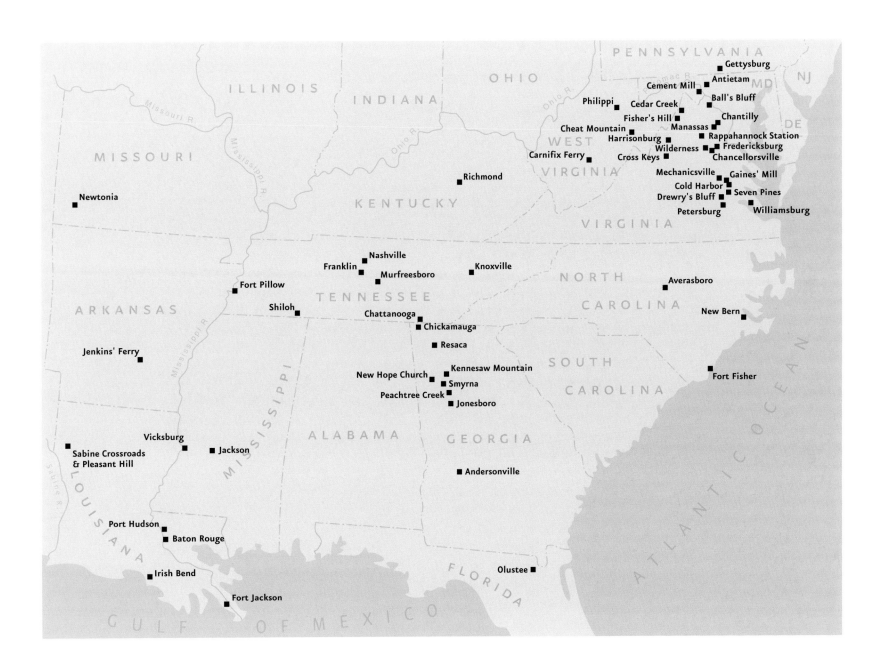

PENNSYLVANIA

OHIO

ILLINOIS

INDIANA

MD

NJ

Gettysburg

Cement Mill

Antietam

Philippi

Cedar Creek

Ball's Bluff

Fisher's Hill

Chantilly

DE

Cheat Mountain

Manassas

MISSOURI

WEST

Harrisonburg

Rappahannock Station

VIRGINIA

Carnifix Ferry

Wilderness

Fredericksburg

Cross Keys

Chancellorsville

Richmond

Mechanicsville

Gaines' Mill

KENTUCKY

Cold Harbor

Seven Pines

Newtonia

VIRGINIA

Drewry's Bluff

Williamsburg

Petersburg

Nashville

Averasboro

Franklin

Knoxville

NORTH

Murfreesboro

CAROLINA

Fort Pillow

New Bern

TENNESSEE

Shiloh

ARKANSAS

Chattanooga

Chickamauga

Jenkins' Ferry

Resaca

SOUTH

Kennesaw Mountain

New Hope Church

CAROLINA

Smyrna

Fort Fisher

Peachtree Creek

Jonesboro

Vicksburg

Sabine Crossroads
& Pleasant Hill

Jackson

ALABAMA

GEORGIA

Andersonville

LOUISIANA

Port Hudson

Baton Rouge

Irish Bend

Olustee

FLORIDA

ATLANTIC OCEAN

Fort Jackson

GULF OF MEXICO

Mississippi R.

Missouri R.

Ohio R.

Sabine R.

BRIEF DESCRIPTIONS
OF THE BATTLES

3 JUNE 1861

PHILIPPI, WESTERN VIRGINIA

A surprise attack at dawn by the Union army initiated a rout of the Confederates. The first leg amputation of the war occurred here. The amputee, J. E. Hangar, invented an artificial limb and founded a company for their manufacture.

21 JULY 1861

FIRST MANASSAS, VIRGINIA

Many expected this first major battle to end the war. Inexperienced soldiers, similarity of uniforms, and poorly executed plans created a very confused battlefield, the advantage moving from one side to the other with charge after charge. Toward the end of the long day, Confederate reinforcements put the Federals to a retreat, which quickly became a rout. Numerous civilians who had come from Washington to picnic and watch the action ended up fleeing in panic with the Union army.

10 September 1861

CARNIFIX FERRY, WESTERN VIRGINIA

The refusal of the Confederate commanders of the two Southern armies in pro-Union western Virginia to cooperate led to one of these armies being pinned against the Gauley River by a superior Federal force. After initial losses of men and supplies, the Confederates were able to withdraw across the ferry during the night.

11–13 September 1861

CHEAT MOUNTAIN, WESTERN VIRGINIA

Heavy rains, the rugged landscape, and misinformation from captured Federals confused the multipronged Confederate attack on this strategic fort. The Southern commander Robert E. Lee withdrew and was labeled "Granny" by the secessionist press. The early Northern victories in western Virginia ultimately led to the partition of the state of Virginia. The new state of West Virginia was admitted to the Union in 1863.

21 October 1861

BALL'S BLUFF, VIRGINIA

Federal commanders wanted "a slight demonstration" near Leesburg to relieve Confederate pressure on a nearby Union division. Seventeen hundred Federals crossed the Potomac at Ball's Bluff with no information about the enemy's location and became trapped in a crossfire from three sides with their backs to a rocky, seventy-foot drop-off. Attempting to escape, men fell to their death, drowned, or were shot while swimming across the river.

9 December 1861

CHUSTO-TALASAH, CHEROKEE NATION, INDIAN TERRITORY

The displaced and resettled Indians in what is now Oklahoma divided into Union and Confederate camps based on previous rivalries and differing perceptions of the warring governments. Indians on both sides owned black slaves. Facing a growing Southern alliance, three thousand Union Indians headed northward for the security of Kansas. The pursuing Confederate force of Creeks, Choctaws, Chickasaws, Cherokees, and Texans attacked the Union group of Creeks, Seminoles, slaves, and escaping slaves for the second time here. The Union Indians held a strong defensive position along Bird Creek, but after several attacks they were forced to retreat. On 19 December the enemies fought again further to the north. This time the Confederates routed the Union warriors, whose families and slaves fled into the winter landscape, many dying from starvation and the cold.

21 February 1862

VALVERDE, NEW MEXICO TERRITORY

With designs upon the entire Southwest, the Confederates launched a campaign against the Federal troops stationed there. At Valverde the Southerners attempted to cut off Union Fort Craig from its headquarters at Santa Fe. The Northerners charged across the Rio Grande to attack the Southern position but were forced back after a vicious counterattack and hand-to-hand fighting. The Confederates went on to occupy Santa Fe.

14 March 1862

NEW BERN, NORTH CAROLINA

South of the Virginia peninsula, where a huge Federal army was moving towards Richmond, the Union army was also invading the North Carolina coast. Federal troops landed unopposed twelve miles from New Bern and marched to attack the Confederate defenses south of the city. After several hours of heavy fighting the Southern line collapsed. The strategic port was occupied that night and held for the rest of the war. Schools were quickly set up for the slaves who fled from nearby plantations to New Bern. The schools were soon shut down, however, as the Federal government attempted to appease the local North Carolinians.

26–28 March 1862

LA GLORIETA PASS, NEW MEXICO TERRITORY

Fighting behind the rocks and trees on the slopes of this narrow canyon along the Santa Fe Trail, the Confederates finally drove the Union forces back on the final day of the battle. But a Federal detachment had circled around during the fighting and completely destroyed the large Southern supply train in the rear. The Confederates were forced to retreat all the way to Texas through the desert in dire need of food and water. The Southern bid for control of the territory was over. Fighting continued here throughout the war between Federal cavalry and hostile Indians.

6–7 April 1862

SHILOH, TENNESSEE

The early morning Confederate attack near Shiloh Church caught the Federals unprepared, and the North steadily lost ground. The ever increasing violence of the first day's fighting culminated in repeated Southern charges on the Union position in the Hornets' Nest. The Confederate commander Albert Johnston was killed here. The Union defenders of this critical site eventually surrendered, but they had allowed the Federal line to solidify behind them. Union reinforcements arrived during the night, and the next day Commander Ulysses S. Grant ordered an offensive and forced the Confederates to retreat. The Union now controlled strategic middle Tennessee and posed a constant threat to the western Confederacy. With its great carnage, Shiloh stunned Americans on both sides with the realization of how terrible the war had become.

18–28 April 1862

FORT JACKSON, LOUISIANA

The Union navy, under Captain David Farragut, pounded this fort at the mouth of the Mississippi River, overwhelmed the Confederate fleet, and then moved upstream to take New Orleans. Cut off, the fort's garrison mutinied and surrendered several days later. The Union now held critical positions on the lower and upper Mississippi.

5 May 1862

WILLIAMSBURG, VIRGINIA

After landing 105,000 men at the tip of the peninsula between the James and York Rivers, the Union command prepared to push northwest toward Richmond. Despite the Federals' overwhelming numbers, poor intelligence and overcaution kept them from attacking the thin Confederate defense line, which stretched from Yorktown across the peninsula. After a month of skirmishing the Federals finally moved, but the Southerners had already evacuated. At Williamsburg the Union army attacked the rear guard of the retreating Confederates without success. The Southerners then launched several poorly coordinated counterattacks, which also failed. Some Confederate regiments lost 50 percent of their soldiers. They withdrew toward Richmond that night.

15 May 1862

DREWRY'S BLUFF, VIRGINIA

The loss of ports on the lower peninsula had crippled the already weak Confederate navy, and nothing barred Union ships from entering Richmond except this hastily fortified bluff and old steamers intentionally sunk in the James River below. But the Federal ironclads were stopped by heavy shelling in a four-hour battle.

31 May 1862
SEVEN PINES, VIRGINIA
The Union army had slowly pushed up the peninsula to within six miles of the Southern capital. A series of severe battles would ensue. The Union commander George McClellan had placed his troops on both sides of the Chickahominy River, which had now reached flood stage. The Confederates attacked the southern wing, but the coordination between their divisions was poor. After several wild attacks and melees, the Southerners, under a new leader, Robert E. Lee, withdrew to their original positions.

6 June 1862
HARRISONBURG, VIRGINIA
Cavalry and infantry charges punctuated this rearguard action, which ended in a mutual retreat. The death of General Turner Ashby, commander of all Confederate cavalry in the Shenandoah Valley, was a setback to General "Stonewall" Jackson's efforts to rid the valley of Federals.

8 June 1862
CROSS KEYS, VIRGINIA
With Union armies converging on his troops from opposite directions, General Jackson's men delayed the eastern Union force by burning a number of bridges. The Confederates engaged the Federals coming from the west and defeated them at Cross Keys by turning back the first Union attack and then counterattacking strongly. The next day they returned to the east and defeated the Union army at Port Republic. In thirty days of extraordinary maneuvering in the Shenandoah Valley, Jackson defeated three Fed-

eral armies and prevented large numbers of reinforcements from reaching other critical Union campaigns.

26 June 1862
MECHANICSVILLE, VIRGINIA
The massive Union army still threatened Richmond. Lee's plan to force the Northerners out of their entrenchments at Mechanicsville by attacking them from different directions was poorly coordinated. A series of frontal charges against strong Union positions resulted in many Southern dead.

27 June 1862
GAINES' MILL, VIRGINIA
Despite continual success and a numerical superiority of two to one, the Union soldiers slowly withdrew from their positions nearest Richmond. They fought off several Confederate charges here but were finally forced back by the evening attack of more than fifty thousand Southerners. Robert E. Lee had taken the offensive and would not relinquish it, despite heavy losses, until the Federal army had retreated well down the peninsula and abandoned its designs on the Southern capital.

5 August 1862
BATON ROUGE, LOUISIANA
Attempting to retake the Louisiana capital, the Confederates attacked in a thick early morning fog. In house-to-house fighting the Federals retreated toward the river and the support of their gunboats. The Southerners were expecting naval support of their own, but their ironclad had engine trouble upriver, and they were forced to

withdraw. The Union troops evacuated the city two weeks later, returning to their strong base in New Orleans.

28–30 August 1862
SECOND MANASSAS, VIRGINIA
Moving back toward Washington, D.C., the Union army was attacked in the late afternoon by Jackson's concealed Confederates, who had circled around to the west. Fighting at close range, the lines fired volley after volley at each other until dark. The next day the Federals made six unsuccessful, bloody assaults on the Southerners, who had withdrawn behind an unfinished railroad cut. The third day began with another Northern charge, followed by a massive counterattack on the Union left by Lee's previously unengaged troops. The Federals fled the field.

29–30 August 1862
RICHMOND, KENTUCKY
The Confederate invasion of Kentucky began here. The Federal army was pushed back from three successive positions, suffering an 80 percent loss. The three-hundred-pound General "Bull" Nelson, trying to rally his Union troops, rode along the front line shouting, "If they can't hit me, they can't hit anything!" He was soon hit twice, furthering the panic of his soldiers. A month later Nelson was murdered by a Union general he had relieved of command. By October the Federals had been heavily reinforced, and they pushed the Confederates out of the state. Kentucky was secured for the Union for the rest of the war.

1 September 1862

CHANTILLY, VIRGINIA

Confederates, pursuing the Federals fleeing from the battle of Second Manassas, encountered a prepared Union rear guard in the late afternoon. Intense lightning, thunder, and rain added to the confusion of the attacks and counterattacks. At nightfall the Federals withdrew toward Washington, leaving the way clear for the first Southern invasion of the North.

17 September 1862

ANTIETAM, MARYLAND

All-out attacks and counterattacks continued throughout the bloodiest day in the Civil War, until both armies were completely spent. The outnumbered Confederates had held their ground, but they retreated back into Virginia the next night. The defeat of the Southern invasion, ending their hopes for European recognition and fresh Maryland recruits, gave Lincoln the opportunity to issue the Emancipation Proclamation.

20 September 1862

CEMENT MILL, WESTERN VIRGINIA

The rear guard of the Confederate army retreating from Antietam was attacked by pursuing Federals at this Potomac ford. The Southerners hurried reinforcements back and stopped the Union troops, many of whom were armed with defective weapons.

13 December 1862

FREDERICKSBURG, VIRGINIA

In another campaign against Richmond the Union army unnecessarily delayed its crossing of the Rappahannock River, allowing the Southern-ers to shore up their weak defenses. After finally crossing the river, the Federals made frontal assaults across mostly open ground against strong Confederate positions all day long. The slaughter was tremendous and useless. The Federals withdrew back across the Rappahannock River.

31 December 1862–2 January 1863

MURFREESBORO, TENNESSEE

Federal troops advancing into central Tennessee from previously occupied Nashville were forced back from their battle line under massive Confederate assaults launched early on 31 December. They rallied and held their position later in the day. Losses were so great that neither army could act the next day. The Southerners attacked in the afternoon of 2 January, but they were repelled and suffered many casualties. The Confederate army withdrew the next day.

14 March–8 July 1863

PORT HUDSON, LOUISIANA

After getting word of the fall of Vicksburg, the defenders of Port Hudson, now the last Confederate stronghold along the Mississippi River, also surrendered. They had withstood two bloody attacks and a siege of forty-eight days. The initial Union assault had involved the first large-scale use of black troops in combat.

12–14 April 1863

IRISH BEND, LOUISIANA

The severely outnumbered Confederates were able to withstand a Union pincers movement against their position on Bayou Teche. After a heavy artillery barrage, the Southerners charged the invaders from Federally held New Orleans.

Then they retreated to safety, while the Union army remained immobile in the swampy terrain.

1–4 May 1863

CHANCELLORSVILLE, VIRGINIA

Defying conventional tactics, Lee split his army two times in the face of a Union army twice his size. Through aggressive maneuvering and attack the Confederates forced the Northerners to retreat. But the South lost one of their best generals; after executing a decisive flank attack on 2 May, "Stonewall" Jackson was accidentally shot by his own men and died a week later.

14 May 1863

JACKSON, MISSISSIPPI

The Union army under Grant landed on the east bank of the Mississippi on 30 April for its second campaign against the strong river fort at Vicksburg. Confused by Grant's advance to the northeast instead of directly north toward Vicksburg, the Southerners were caught with their troops dispersed. An intense delaying action was fought by the Confederates while they evacuated Jackson. The Federals, who had succeeded in isolating the troops at Vicksburg by controlling the railroad link to Jackson, burned much of the latter city.

19 May–4 July 1863

VICKSBURG, MISSISSIPPI

After two unsuccessful attacks, the Union army entrenched and with the navy began a continuous, heavy bombardment of the Confederate lines and the city. Disease-ridden and starving, with the Federal lines creeping ever closer, the

Southerners were finally compelled to surrender this key position on the Mississippi River.

1–3 July 1863
GETTYSBURG, PENNSYLVANIA
After its victory at Chancellorsville, the Confederate army crossed over the Potomac River into Maryland and then moved into southern Pennsylvania in its second invasion of the North. The South hoped to relieve the pressure on Richmond, gather supplies, and generally discourage the North from continuing the costly war. A lone Confederate infantry brigade searching for shoes contacted two Union brigades west of Gettysburg. Reinforcements for both sides arrived, and the fighting reached horrendous proportions. After being driven back on the first day, the Federals regrouped in a strong position on Cemetery Ridge. The Southerners assaulted both Union flanks the next day with little success. On the third day a massive Confederate attack on the center of the Northern line ended in disaster, and the Confederate army retreated the following day. The Union victories here and at Vicksburg marked a turning point in the war. The South would continue fighting for almost two more years but with ever diminishing chances for success.

10–16 July 1863
JACKSON, MISSISSIPPI
After the fall of Vicksburg, the Union army returned to Jackson, which had been reoccupied by Southern troops. After a week-long siege, punctuated by several sharp encounters, the Confederates withdrew on the sixteenth.

13–15 July 1863
NEW YORK, NEW YORK
The selection of the first draftees for the new army conscription act set off three days of rioting by mobs estimated at 50,000 to 100,000 people. A number of blacks were beaten and lynched, a black orphanage was burned down, stores were ransacked, and the police and members of the military were attacked. More troops were called in, some of whom had just fought at Gettysburg; they fired on the crowds, and order was restored.

21 August 1863
LAWRENCE, KANSAS
Partisans of both sides were responsible for massacres and arson along the border between Missouri and Kansas. The Confederate William Quantrill and his band entered Lawrence early in the morning to kill every male capable of holding a gun and to burn the abolitionist community to the ground. In three hours they had finished.

19–20 September 1863
CHICKAMAUGA, GEORGIA
Securing the Chattanooga area was critical for the North if it was to launch an invasion of Atlanta. This first major battle for control of Chattanooga took place just south of the city, near Chickamauga Creek. Attacks surged back and forth through the woods and clearings on the first day with no clear advantage to either side. The battle resumed with the same confused fury on the morning of the twentieth, until a mistaken attempt to close a nonexistent gap in the Union line by shifting troops opened a real gap just as the Confederates attacked. Half of the Union army was immediately routed, and only a desper-

ate delaying action prevented total catastrophe. The Federals retreated into Chattanooga, where they were put under siege by the Southerners.

7 November 1863
RAPPAHANNOCK STATION, VIRGINIA
The Union army surprised the Southerners with a night attack following the afternoon's fighting at the crossing and killed or captured the entire Confederate detachment of fifteen hundred men on the north side of the Rappahannock River. The rest of Lee's army withdrew to the south.

17 November–4 December 1863
KNOXVILLE, TENNESSEE
The second Confederate attempt to remove the Federals from eastern Tennessee was initiated during the stalemate at Chattanooga. Southern troops dispatched from there laid siege to Knoxville. A major attack was launched against the prominent Union defensive position, Fort Sanders, on the twenty-ninth, but heavy fire and icy conditions on the Federal earthworks made them impossible to scale and the assault failed. The Confederates then learned of the defeat in Chattanooga and withdrew from Knoxville.

23–25 November 1863
CHATTANOOGA, TENNESSEE
A little after noon on the twenty-third, two Union divisions marched out between the siege lines and paraded in a formal drill for nearly an hour. Federals rushed the surprised Confederates and within an hour they had pushed them off Orchard Knob. The next day saw a massive Federal push up the slopes of fog-enshrouded Lookout Mountain. After long hours of heavy combat

the Southerners had to retreat from their position on top of the mountain. They also lost ground on the north of Missionary Ridge, where another all-day battle was fought on the twenty-fifth. An unplanned charge up the ridge broke the Confederate center, causing a complete rout and retreat into northern Georgia. The Union had secured a base for its move on Atlanta the next year.

February 1864–April 1865
ANDERSONVILLE, GEORGIA

Unsanitary conditions, extreme heat, disease, shortages of food in the crumbling Southern economy, and the Union's decision to discontinue the exchange of prisoners made Andersonville the worst of the prisoner-of-war camps.

20 February 1864
OLUSTEE, FLORIDA

With the grand design of bringing Florida back into the Union, Federal troops landed in Jacksonville and pushed inland, burning Confederate camps and freeing slaves. Fifty miles from the coast a Southern army blocked their progress, and an intense battle ensued. Through skillful reinforcement and supply of their first line of battle, the Confederates forced the Union army to retreat; the Federals' Florida expedition was over.

8–9 April 1864
SABINE CROSSROADS AND PLEASANT HILL, LOUISIANA

With strategic Shreveport in the balance, the defending Confederates suddenly attacked the vanguard of the Federal Red River expedition with fury. Although numerically superior, the Union

ranks crumbled, and soldiers fled in panic. On the second day the Union army made a determined stand and repulsed the Confederates, but the Federals continued their retreat back to New Orleans.

12 April 1864
FORT PILLOW, TENNESSEE

Nathan Bedford Forrest's Confederate cavalry attacked this Mississippi River fort at dawn and drove the Union defenders back into the center of the earthworks. A call to surrender was refused, and the Southerners swept over the final barriers. The Federals fled down the steep river bluff only to be cut down by Confederates who had circled around. Contradictory reports stated that many black troops were murdered after surrendering.

30 April 1864
JENKINS' FERRY, ARKANSAS

The Union expedition through Arkansas had reached its objective and drawn Southern cavalry away from the Union Red River forces, but Confederate reinforcements forced them to withdraw northward toward Little Rock. The retreating Federals were attacked at Jenkins' Ferry as they crossed a pontoon bridge over the Saline River. Their well-positioned rear guard successfully held off the Confederates until the Union army had cleared the river. Exhausted from the fighting and their previous forced march, the Southerners did not pursue.

5–7 May 1864
WILDERNESS, VIRGINIA

The Union Army of the Potomac, now under the direction of Ulysses S. Grant, began the final

campaign to take Richmond by crossing the Rapidan River in an attempt to turn the right flank of Robert E. Lee's Army of Northern Virginia. They moved south into this thickly forested lowland and immediately attacked at Sanders' field. The Confederates countered, and the confused, vicious fight was on; "bushwacking on a grand scale" was how one participant described it. The woods caught on fire several times, burning the wounded who were unable to move. Neither side could gain a clear advantage. After the battle, however, the Federals continued southward to fight at Spotsylvania Court House.

14–15 May 1864
RESACA, GEORGIA

The Union General William Tecumseh Sherman began his Atlanta campaign out of Chattanooga in early May. During the next four months there would be constant fighting, with continual Federal attempts to flank and trap the Confederates. The armies met at Resaca, where each side launched several costly attacks to no avail. The Union sent troops to the south, threatening the Confederates' supply line and forcing them to withdraw southward.

25–28 May 1864
NEW HOPE CHURCH, GEORGIA

Another Union flanking maneuver to the southwest was anticipated by the Confederates. Assuming a strong position, they repelled two major Federal attacks, inflicting heavy losses. Sherman directed his troops eastward and managed to reach the strategic railroad, forcing the Southern army to retreat toward Atlanta once again.

1–3 June 1864
COLD HARBOR, VIRGINIA

This critical road junction became the focus of Lee's and Grant's armies in the Union drive toward Richmond. Reinforcements were rushed in by both sides. Attacks and counterattacks failed to break the stalemate on the first day. After a day of preparations, the Union army launched a major assault against strong entrenchments on 3 June. In less than a half-hour seven thousand Federal soldiers were killed or wounded. Grant ordered a withdrawal to the southeast.

15 June 1864–2 April 1865
PETERSBURG, VIRGINIA

The ten months of trench warfare at Petersburg were punctuated with several unsuccessful large-scale attacks, including the one launched after the detonation of four tons of gunpowder under the Confederate line. The Union steadily extended its line westward to a length of more than thirty miles, stretching the outnumbered Southerners to the breaking point. On 1 April 1865, at Five Forks, Federal soldiers overwhelmed the Confederate right flank. The next day Grant ordered an assault that finally broke through the main line. Lee managed to extricate a large portion of his army, but Petersburg and Richmond were lost. Lee surrendered on 9 April at Appomattox Court House.

27 June 1864
KENNESAW MOUNTAIN, GEORGIA

In the morning the Union army staged two massive frontal attacks on the entrenched Confederate line. In vicious fighting, often hand to hand,

the Federals made some small gains at a terrible price. After a standoff lasting a few days, the Union resumed its flanking actions, making it necessary for the Southerners to move even closer to Atlanta.

July 1864–June 1865
ELMIRA, NEW YORK

Poor diet and sanitation, inadequate housing, and the cold climate made the prisoner-of-war camp at Elmira the worst of the Union camps, with a 24 percent mortality rate, just slightly below that of the Southern camp at Andersonville.

2–5 July 1864
SMYRNA, GEORGIA

Another thwarted Federal attack led to another sideways move by the Union army and a retreat by the Confederates.

20 July 1864
PEACHTREE CREEK, GEORGIA

The Confederates attacked one of the three advancing columns of the Union army three miles north of Atlanta. The Southerners almost broke the Federal line in several places, but Union resistance stiffened, and the Confederates withdrew back into the city's defenses.

31 August–1 September 1864
JONESBORO, GEORGIA

Knowing that the defenses of Atlanta were still too strong to be taken, Union troops moved south of the city to cut the vital railroad. In a futile effort to stop the inevitable, outnumbered Confederates fought for two days at Jonesboro.

Their initial attack failed on the first day, and their defensive line was broken on the second day. With their defeat, the Confederate supply line was severed, and the Southerners were compelled to evacuate Atlanta.

19 September 1864
SECOND CABIN CREEK, CHEROKEE NATION, INDIAN TERRITORY

The Civil War in Indian Territory had become a brutal conflict involving raids and killing. After an attack at Flat Rock, the Confederate Cherokees, Creeks, Seminoles, and Texans moved in the direction of a reported Federal supply train. They encountered the large wagon train and its escort, including Union Cherokees, at the small, enclosed outpost on Cabin Creek. Beginning at two o'clock in the morning, the Southerners attacked repeatedly and finally smashed the Union defense. Later that day the Confederates successfully defended their captured supplies against Union pursuit.

22 September 1864
FISHER'S HILL, VIRGINIA

Weary from its defeat at the Third Battle of Winchester, the Confederate Army of the Valley took a strong defensive position atop Fisher's Hill but was unable to maintain it against attacks from the front and the left flank. Only the darkness of early evening prevented the total capture of the routed Southerners. The Federals now began the destruction of the civilian economy in the Shenandoah Valley.

19 October 1864
CEDAR CREEK, VIRGINIA

Desperate for a victory in the Shenandoah Valley, the Confederates marched all night, attacked before dawn, and overran much of the Union camp. Instead of pursuing the fleeing Federals, the Southerners, tired and hungry, stopped to loot the camp. The Union soldiers formed a line to the north, from which they counterattacked and routed the Confederates later that day. This important Union victory and the capture of Atlanta assured President Lincoln's reelection in November.

25 October 1864
MINE CREEK AND LITTLE OSAGE, KANSAS

The twelve thousand Southerners under Sterling Price had entered Missouri hoping to capture St. Louis and return the state to the Confederacy, but a decisive defeat in Westport forced them to withdraw. The pursuing Federals caught up to the Confederates and broke their hastily set up defensive lines at Mine Creek and then at the Little Osage River. Many soldiers and cannon were captured from Price's army.

28 October 1864
NEWTONIA, MISSOURI

For the last time in Price's ill-fated campaign the Confederates fought off and delayed the Union pursuit while the main body of Southerners retreated. In about a month's time the ill-equipped Confederate army had fought forty-three engagements and lost half its men.

30 November 1864
FRANKLIN, TENNESSEE

Attempting to pull the Federal army out of Georgia, forty thousand soldiers of the Confederate army that had evacuated Atlanta moved north into Tennessee toward the Union-occupied area around Nashville. They pursued and attacked twenty-eight thousand Federals at Franklin by relentless charging over two miles of flat ground. The Southerners broke the first Union line but were cut to pieces at the second line of entrenchments. The slaughter of Confederates was worse than at their final charge at Gettysburg. The Union army withdrew to Nashville that night.

15–16 December 1864
NASHVILLE, TENNESSEE

With the Confederate army encamped outside Nashville's defenses, the Federals prepared their attack for two weeks. Their plan worked well, and they crushed the once powerful Army of Tennessee in front of thousands of spectators lining the hills. The Southerners who were able to retreat were pursued continuously.

27 December 1864–15 January 1865
FORT FISHER, NORTH CAROLINA

Wilmington was the last Southern seaport to remain open. To close it, the Union had to capture coastal Fort Fisher. The first attempt, in late December 1864, failed miserably, but the Federal army and navy returned on 13 January 1865. Troops were landed above the fort on the peninsula to prevent reinforcement from the north, and the large fleet opened up with a tremendous cannonade. Marines attacked the north side of the large earthworks, and brutal fighting at close quarters ensued. The great fort capitulated. Wilmington was occupied by Union troops in February.

16 March 1865
AVERASBORO, NORTH CAROLINA

With Sherman's Federal columns pressing northward from South Carolina seeking to join the Union army moving west from the coast, the Confederates entrenched in front of the invasion from the south. Heavy fighting raged along the main line, until the Southerners were forced back by a threat to their flank. Darkness ended the combat at the second position, and the Confederates withdrew. The Southern army was forced to retreat again at Bentonville a few days later, and they surrendered within a month.

OWNERSHIP
OF THE BATTLEFIELDS

They fought in thousands of places. The preservation of all these sites is obviously impractical and, in fact, not wholly desirable. There is a certain beauty and optimism in a peaceful neighborhood located on what was once a killing ground. But the facts and lessons of history, so vital for social progress, must not be lost. The major battlefields are a living, physical embodiment of critical change and must be preserved. They remind us of our ideals. They are fitting monuments to those who gave everything for their country. To preserve them is to honor these soldiers and study their legacy.

The following list includes only the most significant landowners, in order of importance:

Andersonville, Georgia, *national park*
Antietam, Maryland, *national park*
Averasboro, North Carolina, *private*
Ball's Bluff, Virginia, *county park*
Baton Rouge, Louisiana, *private*
Carnifix Ferry, western Virginia, *state park*
Cedar Creek, Virginia, *private*
Cement Mill, western Virginia, *private*
Chancellorsville, Virginia, *private and national park*
Chantilly, Virginia, *private*

Chattanooga, Tennessee, *private and national park*
Cheat Mountain, western Virginia, *private and national forest*
Chickamauga, Georgia, *national park*
Chusto-Talasah, Cherokee Nation, Indian Territory, *private*
Cold Harbor, Virginia, *private and national park*
Cross Keys, Virginia, *private*
Drewry's Bluff, Virginia, *national park*
Elmira, New York, *private and city park*
First Manassas, Virginia, *national park*
Fisher's Hill, Virginia, *private*
Fort Fisher, North Carolina, *state park*
Fort Jackson, Louisiana, *state park*
Fort Pillow, Tennessee, *state park*
Franklin, Tennessee, *private*
Fredericksburg, Virginia, *private and national park*
Gaines' Mill, Virginia, *private*
Gettysburg, Pennsylvania, *national park*
Harrisonburg, Virginia, *private*
Irish Bend, Louisiana, *private*
Jackson, Mississippi, *private and city park*
Jenkins' Ferry, Arkansas, *state park*
Jonesboro, Georgia, *private*
Kennesaw Mountain, Georgia, *national park*
Knoxville, Tennessee, *private*
La Glorieta Pass, New Mexico Territory, *private and national forest*
Lawrence, Kansas, *private*

Mechanicsville, Virginia, *private and national park*
Mine Creek and Little Osage, Kansas, *state park and private*
Murfreesboro, Tennessee, *national park and private*
Nashville, Tennessee, *private*
New Bern, North Carolina, *private and county*
New Hope Church, Georgia, *private and state park*
New York, New York, *private*
Newtonia, Missouri, *private*
Olustee, Florida, *state park and private*
Peachtree Creek, Georgia, *private and city park*
Petersburg, Virginia, *private and national park*
Philippi, western Virginia, *private*
Port Hudson, Louisiana, *state park and private*
Rappahannock Station, Virginia, *private*
Resaca, Georgia, *private*
Richmond, Kentucky, *private*
Sabine Crossroads and Pleasant Hill, Louisiana, *private and state park*
Second Cabin Creek, Cherokee Nation, Indian Territory, *private and state park*
Second Manassas, Virginia, *national park*
Seven Pines, Virginia, *private*
Shiloh, Tennessee, *national park*
Smyrna, Georgia, *private*
Valverde, New Mexico Territory, *private*
Vicksburg, Mississippi, *national park*
Wilderness, Virginia, *private and national park*
Williamsburg, Virginia, *private*

THE HISTORICAL PHOTOGRAPHERS

Working under difficult circumstances, some two thousand photographers left an extensive documentation of America's Civil War. Never before had such truthful visual statements about war been made of the participants, their damaged bodies, and the destruction of farms and towns. Like many other materials in the South, photographic chemicals were difficult to come by, and Southern photographers economized by concentrating primarily on studio portraits of the soldiers.

GEORGE N. BARNARD had worked in photography for almost twenty years before the Civil War, producing portraits and landscapes. His memorable daguerreotypes of the 1853 Oswego, New York, mill fire are some of the first of the news type ever produced. Barnard worked with Mathew Brady's photographic group briefly in 1862 and then worked for the Union army, producing views of the battlefields of Tennessee and Sherman's Atlanta campaign. These pictures of environmental destruction were mounted in a book he published just after the war. He continued working in photography until his death at the turn of the century.

MATHEW BRADY was a successful portrait photographer with studios in New York and Washington when the Civil War broke out. He accompanied the Union army to the battle of the First Manassas and ended up fleeing back to Washington in the rout. He then hired and organized a number of very capable photographers to cover the war. By the war's end he had amassed the most complete and accurate portrayal of war to date, but the project was a financial failure. After the intense suffering of the war people simply did not want photographic reminders. His collection of 5,700 negatives was finally purchased by the U.S. government in 1875. Brady died in a charity hospital twenty-one years later.

GEORGE S. COOK had some twenty-five years of photographic experience before the start of the war. He had worked for Mathew Brady for a time, and he had opened several of his own portrait studios. He was in Charleston, South Carolina, just before the start of the fighting and made photographs of the Union garrison. He continued to work out of Charleston during the war, being employed by the Confederate army for a time. His image of Fort Sumter under actual bombardment in 1863 is quite rare in showing an actual artillery explosion. After the war, Cook ran several portrait studios until his death in 1902.

ALEXANDER GARDNER, a Scottish immigrant, was a manager and photographer working in Mathew Brady's Washington studio at the onset of the war. Gardner became a major impetus in Brady's photographic coverage of the war, but like all the other photographers who worked for Brady, he received no acknowledgment. All photographs produced under the employ of Brady were attributed to Brady. Gardner, along with Timothy O'Sullivan, quit in 1863 and formed his own photographic corps, giving the individual photographers credit for the work they produced. After the war, he published the best of his company's work in *A Photographic Sketchbook of the Civil War* and then went west to photograph the developing frontier.

TIMOTHY O'SULLIVAN, an Irish immigrant, worked for Mathew Brady's portrait studio before the war and continued with him for the first years of the war. When Alexander Gardner left Brady in 1863, O'Sullivan went with him, becoming the

premier field photographer in the new photographic group. His images of Antietam, Gettysburg, and Grant's last campaign against Richmond are among the most well known photographs of the Civil War. After 1865 O'Sullivan traveled west with several scientific expeditions and produced powerful pictures of the new territories. He died in his early forties from tuberculosis.

ANDREW J. RUSSELL was one of the few photographers actually in the Union army. Captain Russell's primary objective was to accompany the army engineer Herman Haupt and photograph the construction of the railroad lines and trestles in Virginia. He was present at some of the major campaigns and made many effective photographs of the preparations and results. After the war, he was the official photographer for the Union-Pacific Railroad, documenting its construction of track westward.

BIBLIOGRAPHY

Barnard, George N. *Photographic Views of Sherman's Campaign.* New York: Dover, 1977.

Catton, Bruce. *The Centennial History of the Civil War.* 3 vols. Garden City, N.Y.: Doubleday & Co., 1961–65.

Civil War Times Illustrated. 1984–99.

Davis, George B., Leslie J. Perry, and Joseph W. Kirkley, eds. *Atlas to Accompany the Official Records of the Union and Confederate Armies.* 2 vols. Washington, D.C.: Government Printing Office, 1891–95.

Davis, William C., ed. *The Image of War.* 6 vols. Garden City, N.Y.: Doubleday & Co., 1981–84.

———. *Touched by Fire.* Boston: Little, Brown, & Co., 1985.

Eaton, Edward, ed. *Original Photographs Taken on the Battlefields during the Civil War of the United States.* Hartford, Conn.: Edward B. Eaton, 1907.

Faust, Patricia L., ed. *Historical Times Illustrated Encyclopedia of the Civil War.* New York: Harper & Row, 1986.

Foote, Shelby. *The Civil War: A Narrative.* 3 vols. New York: Random House, 1958.

Gardner, Alexander. *Gardner's Photographic Sketch Book of the Civil War.* Washington, D.C.: Philp & Solomons, 1866.

Holmes, Oliver Wendell. "Doings of the Sunbeam." *Atlantic Monthly* 13 (1863).

Janes, Henry, M.D. "Medical Record Book of Dr. Henry Janes." Montpelier, Vt., 1861–65. Special Collections, Bailey/Howe Library, University of Vermont, Burlington.

Johnson, Robert, and Clarence Buel, eds. *Battles and Leaders of the Civil War.* 4 vols. New York: Century Co., 1887–88.

McCardell, John. *The Idea of a Southern Nation.* New York: W. W. Norton & Co., 1979.

McPherson, James M. *Battle Cry of Freedom.* New York: Oxford University Press, 1988.

———. *What They Fought For, 1861–1865.* Baton Rouge: Louisiana State University Press, 1994.

———, ed. *Battle Chronicles of the Civil War.* 6 vols. New York: Macmillan, 1989.

Mead, George Herbert. *Selected Writings.* Indianapolis: Bobbs-Merrill, 1964.

Milhollen, Hirst D., Milton Kaplan, Helen Stuart, and David Donald, eds. *Divided We Fought.* New York: Macmillan, 1956.

Miller, Francis, ed. *The Photographic History of the Civil War.* 10 vols. New York: Review of Reviews Co., 1911.

Paz, Octavio. *One Earth, Four or Five Worlds.* San Diego: Harcourt Brace Jovanovich, 1985.

Russell, Andrew J. *Russell's Civil War Photographs.* New York: Dover, 1982.

Sweet, Timothy. *Traces of War.* Baltimore: Johns Hopkins University Press, 1990.

Trachtenburg, Alan. *Reading American Photographs.* New York: Hill & Wang, 1989.

United States Military Academy, Department of Military Art and Engineering. *Civil War Atlas to Accompany Steele's American Campaigns.* West Point, N.Y., 1941.

United States War Department. *The War of the Rebellion: A Compilation of the Official Records of the Union and Confederate Armies.* 128 vols. Washington, D.C.: U.S. Government Printing Office, 1880–1900.

Westbrook, Robert. *History of the 49th Pennsylvania Volunteers.* Altoona, Pa.: Altoona Times, 1898.

MAP AND PICTURE CREDITS

In the list below, the name of the photographer, artist, or mapmaker, if known, precedes the current source. Most photographs are reproduced in their entirety. Some borders have been changed because of damage to the photographs or for format reasons. Plates and maps are listed by page number.

FIGURES

Page 2. Montgomery Meigs; Prints and Photographs Division, Library of Congress

Page 6. Massachusetts Commandery Military Order of the Loyal Legion and the U.S. Army Military History Institute

1. Dale Snair Collection

2. Mathew Brady or associate; Prints and Photographs Division, Library of Congress

3. National Archives, Washington, D.C.

4. Timothy O'Sullivan; Massachusetts Commandery Military Order of the Loyal Legion and the U.S. Army Military History Institute

5. Massachusetts Commandery Military Order of the Loyal Legion and the U.S. Army Military History Institute

6. Alexander Gardner; Prints and Photographs Division, Library of Congress

7. George N. Barnard; Georgia Department of Archives and History, Atlanta

8. Massachusetts Commandery Military Order of the Loyal Legion and the U.S. Army Military History Institute

9. Chicago Historical Society

10. Timothy O'Sullivan; Massachusetts Commandery Military Order of the Loyal Legion and the U.S. Army Military History Institute

11. George S. Cook; Massachusetts Commandery Military Order of the Loyal Legion and the U.S. Army Military History Institute

12. Armstead & White; Chicago Historical Society and Prints and Photographs Division, Library of Congress

PLATES

22. Michael J. McAfee

24. Reed B. Bontecou, M.D.; Otis Historical Archives, National Museum of Health and Medicine, Armed Forces Institute of Pathology, Washington, D.C.

27. Timothy O'Sullivan; Eaton, *Original Photographs Taken on the Battlefields,* 80

28. Davis, Perry, and Kirkley, *Atlas to Accompany the Official Records of the Union and Confederate Armies,* vol. 1, pl. 9, no. 1

30. Otis Historical Archives, National Museum of Health and Medicine, Armed Forces Institute of Pathology, Washington, D.C.

32. John Reekie; The Western Reserve Historical Society, Cleveland, Ohio

34. Janes, "Medical Record Book of Dr. Henry Janes"

36. Otis Historical Archives, National Museum of Health and Medicine, Armed Forces Institute of Pathology, Washington, D.C.

39. Timothy O'Sullivan and Alexander Gardner; Prints and Photographs Division, Library of Congress

40. George N. Barnard; Prints and Photographs Division, Library of Congress

44. Chicago Historical Society

46. Jacob Wells; Johnson and Buel, *Battles and Leaders of the Civil War,* 2:126

49. J. O. Davidson; Johnson and Buel, *Battles and Leaders of the Civil War,* 2:40

50. Archives and Manuscripts Division, Oklahoma Historical Society

52. Otis Historical Archives, National Museum of Health and Medicine, Armed Forces Institute of Pathology, Washington, D.C.

54. Massachusetts Commandery Military Order of the Loyal Legion and the U.S. Army Military History Institute

56. Eaton, *Original Photographs Taken on the Battlefields,* 66

58. George N. Barnard; Prints and Photographs Division, Library of Congress

60. Alexander Gardner; Prints and Photographs Division, Library of Congress

62. *Left to right:* for Thomas Rushin, Georgia Department of Archives and History; for John Clark, Monroe County Historical Commission, Monroe, Michigan; for William Parran, Museum of the

182

Confederacy, Richmond, Va.; and for Charles King, Westbrook, *History of the 49th Pennsylvania Volunteers*

64. Andrew J. Russell; Prints and Photographs Division, Library of Congress

66. Massachusetts Commandery Military Order of the Loyal Legion and the U.S. Army Military History Institute

70. Mathew Brady; Prints and Photographs Division, Library of Congress

72. Miller, *Photographic History of the Civil War,* 1:205

74. National Archives, Washington, D.C.

78. John Reekie and Alexander Gardner; Prints and Photographs Division, Library of Congress

80. Tim Landis

82. Herb Peck Jr.

85. Prints and Photographs Division, Library of Congress

86. Old Court House Museum, Vicksburg

88. Prints and Photographs Division, Library of Congress

90. Samuel Reader; Kansas State Historical Society, Topeka

92. State Historical Society of Missouri, Columbia

94. Andrew D. Lytle, Louisiana and Lower Mississippi Valley Collections, LSU Libraries, Louisiana State University, Baton Rouge

98. Massachusetts Commandery Military Order of the Loyal Legion and the US Army Military History Institute

100. *Harper's Weekly,* 1 August 1863

102. Museum of the Confederacy, Richmond

104. A. J. Riddle; National Archives, Washington, D.C.

108. Timothy O'Sullivan and Alexander Gardner; Prints and Photographs Division, Library of Congress

110. Otis Historical Archives, National Museum of Health and Medicine, Armed Forces Institute of Pathology, Washington, D.C.

113. Otis Historical Archives, National Museum of Health and Medicine, Armed Forces Institute of Pathology, Washington, D.C.

114. National Archives, Washington, D.C.

116. Otis Historical Archives, National Museum of Health and Medicine, Armed Forces Institute of Pathology, Washington, D.C.

119. Minnesota Historical Society, St. Paul

120. George N. Barnard; Massachusetts Commandery Military Order of the Loyal Legion and the U.S. Army Military History Institute

122. George N. Barnard; Prints and Photographs Division, Library of Congress

124. Alexander Gardner; Prints and Photographs Division, Library of Congress

126. © Collection of The New-York Historical Society

128. Massachusetts Commandery Military Order of the Loyal Legion and the U.S. Army Military History Institute

130. Massachusetts Commandery Military Order of the Loyal Legion and the U.S. Army Military History Institute

133. The Battle of Pleasant Hill, Inc.

134. George N. Barnard; Prints and Photographs Division, Library of Congress

136. Massachusetts Commandery Military Order of the Loyal Legion and the U.S. Army Military History Institute

138. Special Collections, Robert W. Woodruff Library, Emory University

140. George N. Barnard; Prints and Photographs Division, Library of Congress

143. George N. Barnard; Prints and Photographs Division, Library of Congress

144. Massachusetts Commandery Military Order of the Loyal Legion and the U.S. Army Military History Institute

148. Massachusetts Commandery Military Order of the Loyal Legion and the U.S. Army Military History Institute

150. Old Court House Museum, Vicksburg

152. Ellis County Museum, Inc.

154. Prints and Photographs Division, Library of Congress

156. Chicago Historical Society

158. Otis Historical Archives, Armed Forces Medical Museum, Armed Forces Institute of Pathology, Washington, D.C.

160. T. C. Roche; Prints and Photographs Division, Library of Congress

MAPS

164, 165. Adapted from: Miller, *Photographic History of the Civil War,* vol. 1, frontispiece

ACKNOWLEDGMENTS

Thank you, Suzanne, Sara Blaise, and Maura, for your patience during my many trips away from home; Colonel Thomas Moore Huddleston, for sharing your experience and insight into the United States Army; George F. Thompson and Randall B. Jones, of the Center for American Places, for your inspired and intelligent development of this project; Joanne Allen, for editing the text; and Robert Adams, Ira Beryl Brukner, Frank Gohlke, Bill Hart, Dan Leavy, and Kit Wilson, for your forthright criticism and support during the evolution of this work.

Thanks also to Middlebury College, the Andrea Frank Foundation, and the Ada Howe Kent Foundation, for your generous financial support. And finally, thanks to the individuals from the historical societies, museums, and photographic archives; the national and state battlefield parks; local libraries; the Middlebury College Library and Slide Library; landowners who permitted trespass; and private collectors.

183

INDEX TO BATTLEFIELDS

JOHN HUDDLESTON was born in 1952 on the U.S. Army base at Fort Bragg, North Carolina, and was raised in a family with a long military tradition. Mr. Huddleston received his B.A. in psychology from Yale University and completed his M.F.A. in photography at San Francisco State University. Since 1987 he has taught visual art at Middlebury College, where he is a full professor. Mr. Huddleston's photographs are in the permanent collections of the High Museum of Art in Atlanta, the Bibliothèque Nationale in Paris, the Chase Manhattan Bank in New York City, the First National Bank of Boston, and the Berkeley Art Museum. He has exhibited at the Chrysler Museum of Art in Norfolk, Virginia, Wave Hill and the Scott Pfaffman Gallery in New York City, the Massachusetts Institute of Technology Museum in Cambridge, San Francisco Camerawork, and the Triton Museum in Santa Clara, California. His photographs have appeared in *Harper's, Preservation,* the *New England Review,* and *DoubleTake,* among others. Mr. Huddleston's video work has received awards from London to Tokyo. He won an Andrea Frank Foundation Grant for *Killing Ground.*

KILLING GROUND by John Huddleston

Designed by Glen Burris and set by the designer in
Eureka Sans and Adobe Garamond. Separated and
printed on 150 gsm Biberist Matte by Eurografica.

Library of Congress Cataloging-in-Publication Data

Huddleston, John, 1952–

 Killing ground : the Civil War and the changing
American landscape / John Huddleston.

 p. cm. — (Creating the North American
landscape)

 "This book has been brought to publication
with the generous assistance of the Andrea Frank
Foundation and Middlebury College"—T.p. verso.

 Includes index.

 ISBN 0-8018-6773-8 (hardcover : alk. paper)

 1. United States—History—Civil War, 1861–
1865—Battlefields—Pictorial works. 2. United
States—History—Civil War, 1861–1865—Social
aspects. 3. United States—History—Civil War,
1861–1865—Influence. 4. War and society—
United States. 5. Historic sites—United States—
Pictorial works. 6. Landscape—United States—
Pictorial works. 7. Landscape—Social aspects—
United States. I. Middlebury College. II Title.
III. Series.

 E468.7 .H83 2002

 973.7—dc21 2001000238